Alessandro Angelini

PIERO DELLA FRANCESCA

SCALA/RIVERSIDE

CONTENTS

© Copyright 1985 by SCALA, Istituto Fotografico
Editoriale S.p.A., Antella (Florence)
Editors: Daniele Casalino and Karin Stephan
Translator: Lisa Pelletti
Layout: Fried Rosenstock
Photographs: SCALA (A. Corsini, M. Falsini, M. Sarri)
except pages 60, 61 (Frick Collection, New York), page
14 (Gemäldegalerie Dahlem, Staatliche Museen, Berlin),
pages 8, 62, 75, 76, 77 (National Gallery, London)
Produced by SCALA
Printed in Italy by: Amilcare Pizzi S.p.A.-arti grafiche
Cinisello Balsamo (Milan), 1997

The Formative Years: Florence 1435-40

The scarcity of information about the painting of Piero della Francesca in the artistic literature of the time must not make us underestimate the importance of his art in the varied and complex context of Italian 15th-century painting. The fact that Piero was born and spent many years in Borgo San Sepolcro, and worked almost all his life far away from a literary and artistic centre such as Florence, certainly contributed to the lack of information about his activity. With a few exceptions, in fact, Piero was entirely ignored by his contemporaries. It was not until Vasari wrote his biography in 1550 that the literary sources began to pay any attention to Piero's painting. Until then the only interest had been shown by artists working at the same time as Piero, who had been in contact with his paintings and whose work showed his influence. But none of our literary sources, not even Vasari, realized that Piero della Francesca was more than any other Italian 15th-century painter responsible for the development of Florentine Renaissance painting and for the spreading of the principles of the new art throughout Italy. And nowhere in the artistic literature of the Renaissance is it recognized that Piero's work represents one of the highest moments of synthesis between Italian painting and its interest in perspective and space, on the one hand, and Netherlandish painting, on the other, with its study of light and natural phenomena. Here we shall see how Piero's painting can be examined in terms of the progressive development of his original style—a strictly Florentine perspective-based art—towards a more Northern kind of painting, which rapidly conquered the European art world of the late 15th century with its brightly coloured, almost enamel-like, surfaces. Vasari, with a remarkable critical intuition, seems to sense the co-existence of these two elements in Piero della Francesca's painting. In his biography of Piero, he stresses the 'perspective,' the 'measure' and the 'foreshortening' as essential characteristics of Piero's compositions. But at the same time, in his description of the frescoes in the church of San Francesco in Arezzo, he emphasizes the admirable play of light in the obscurity of a night scene, or the shining armour in the *Battle between Heraclius and Chosroes*. Vasari's keen eye even goes further in his understanding of Piero's style: while pointing out the importance of Piero's 'sweet and new manner' in the artistic development of contemporary painters, he actually seems to be stressing that it also influenced a great deal of early 16th-century Venetian art. On the other hand, Vasari was a man of the 16th century, with a taste for 'grace,' 'feelings' and emotions; Piero's figures, with their aloof detachment, must have been more difficult for him to understand.

Whereas Vasari's biography of Piero is, from the critical point of view, so rich in penetrating observations on his paintings, as far as biographical information is concerned, the historian from Arezzo would seem to be rather confused and elusive: he does not mention Piero's formative period spent in Florence, nor does he appear to know that the young artist had been a pupil of Domenico Veneziano, a fact that is proved by contemporary documents as well as by the obvious influence of Domenico in Piero's early works. But Piero's painting, at the height of his artistic development, must have seemed culturally light years away from Florentine mid-15th-century art, and it would have been difficult for Vasari, who had no access to the documents of the time, to suggest that Piero had spent his formative years in Florence. In fact, even in modern times, the difficulty of finding historical explanations for Piero's initial stylistic development caused scholars to propose very different theories. It was not until the first decades of this century—primarily thanks to Roberto Longhi's research on Piero—that we were able to clarify the artist's basic cultural development. To this day, Longhi's study is still the most complete examination of the great art of Piero della Francesca.

Early biographical information on the artist is scarce: we do not even know in what year he was born. Even later, as we shall see, we have very little definite information on his life, which was in any case lacking in memorable events, almost entirely consecrated to the art of painting. We know that Piero was born in Borgo San Sepolcro, in a family of artisans and merchants, probably sometime between 1415 and 1420.

The fact that he was born in a small town in the Tuscan countryside, with no established local traditions, and so different from the large cities such as Florence and Siena, is very significant. Piero did not have a cultural homeland or ancient artistic roots to

follow and abide by; and very early on he moved away from his home town, embarking on his search for a new art.

The fundamental element in Piero's youth is his stay in Florence; he arrived in the city perhaps even before he was twenty years old. The only certain piece of information we have about this important formative period is that in September 1439 Piero was definitely in Florence, where he worked with Domenico Veneziano on the frescoes in the choir of the church of Sant'Egidio. This is where Piero della Francesca's career as a painter begins.

Florence in the 1430s was Italy's most lively and modern artistic centre. The fathers of the early Renaissance, Brunelleschi and Donatello, were at the height of their careers and their fame. The more modern and up-to-date painters were by this time all following the new ideas of Masaccio, trying to adapt the extraordinary and 'terrible' aspect of his figurative revolution to more traditional artforms. It was during this remarkable decade that Leon Battista Alberti returned to Florence, after the bitter years of exile he and his family had undergone; in 1436 with his *De Pictura* he had produced the first theoretical treatise on the new art 'created' by Brunelleschi and Donatello. Some passages of Alberti's treatise undoubtedly call to mind ideas realized in painting by Piero della Francesca. *De Pictura* is the result of Alberti's study of the works of Fra Angelico, Paolo Uccello and Domenico Veneziano, as well as the outcome of the lively scientific and artistic debate whose protagonists were not only Brunelleschi, Paolo Toscanelli and Alberti himself, but all the major scholarly figures of early Humanism in Florence.

In the field of painting this period was marked by an extremely rapid evolution of knowledge and by innumerable developments which soon were to transform the very concept of painting as a trade. Alberti's work, and later Piero's, were decisive in giving artists a new social standing, for artists now needed to have a theoretical background as well.

And it was also during Piero della Francesca's formative period spent in Florence that the first elements of Northern painting began to filter into Florentine and Italian figurative culture: they were destined to influence the most progressive Italian painters for the rest of the century.

Whether one is investigating the Northern origins of Piero's teacher, Domenico Veneziano, or one examines the frescoes by the Portuguese artist Giovanni di Consalvo in the Chiostro degli Aranci in the church of Badia (1436-39), which must have been so rich in transparent textures and colours, or one considers the translucid vase that Filippo Lippi placed in his *Annunciation* in San Lorenzo. . . in all these cases we are confronted with a civilization and a culture which is pro-

1

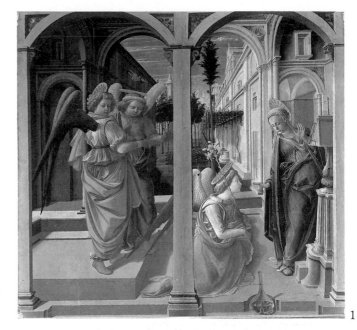

1

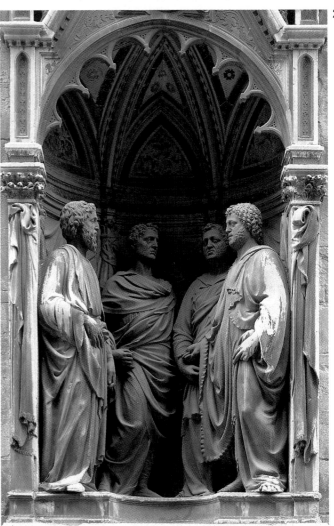

2

1. Filippo Lippi
Annunciation
Florence, San Lorenzo

2. Nanni di Banco
Four Crowned Saints
Florence, Orsanmichele

foundly different from the austere and heroic nature that characterizes Masaccio's apostles (1424-28), or from the classical Roman 'gravitas' of Nanni di Banco's *Four Crowned Saints* at Orsanmichele (1415-20). This new 'chromatic' art of the painters in the 1430s on the one hand adopts Donatello and Masaccio's linear perspective, while on the other attempting to rediscover all those values that late-Gothic use of colour had been based on, and which will be fundamental to the new vision of Netherlandish painting.

In Florence, probably as early as 1435, Piero della Francesca was able to study Fra Angelico's masterpieces, such as the *Coronation of the Virgin*, painted originally for the church of San Domenico in Fiesole and now in the Louvre, and the extraordinary San Marco polyptych: two great paintings created in the critical years of that decade. Here Fra Angelico placed his compositions in an airy spatial environment, even succeeding in making his figures monumental; he then covered the whole with brilliant colours, like a precious enamelled gem. And we must not forget the influence that Paolo Uccello's early works must have had on Piero: the frescoes in Prato Cathedral, the monument to *John Hawkwood* in Florence Cathedral (1436), and above all the three panels depicting the *Battle of San Romano,* painted for Cosimo de' Medici in 1438-40. Paolo Uccello, in fact, was primarily interested in perspective, in the study of the basic structure of shapes, in the almost geometrical simplification of volumes: his figures are like archaic prototypes of Piero's. Further evidence of common interests of Paolo Uccello and the young Piero is offered by a drawing, now in the Uffizi, showing a schematic geometrical representation of a vase. Traditionally attributed to Paolo Uccello, the drawing seems much closer to the static and imposing stance of figures and objects painted by Piero. All the more so since it fits the description of a vase made by Vasari in his biography of Piero: "a vase drawn in squares and faces, in such a way that one can see the front, the back, the sides, the bottom and the mouth."

Piero's study and research cannot have involved only the novelties of contemporary art; like all other great early 15th-century artists, he must also have studied those examples of 14th-century painting which, although painted a century earlier, were the true beginning of the Renaissance in the figurative arts. He would probably have had great interest in spacious and brightly coloured works, like Maso di Banco's frescoes in Santa Croce which, with their large figures of saints depicted in solemn poses, could almost be the work of a Giottesque Piero della Francesca.

But let us return to that document of 1439 that confirms Piero's presence, together with his master Domenico Veneziano, in Sant'Egidio, working on the choir. Unfortunately, this cycle of frescoes has not survived, but it must have been remarkably imposing,

3

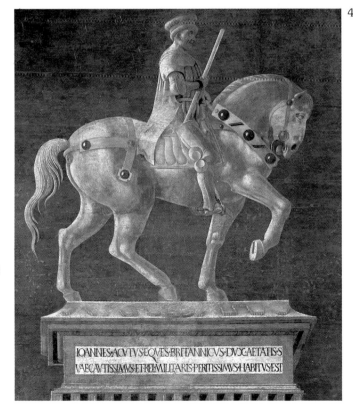

4

3. Fra Angelico
Coronation of the Virgin
Paris, Louvre

4. Paolo Uccello
John Hawkwood
Florence, Cathedral

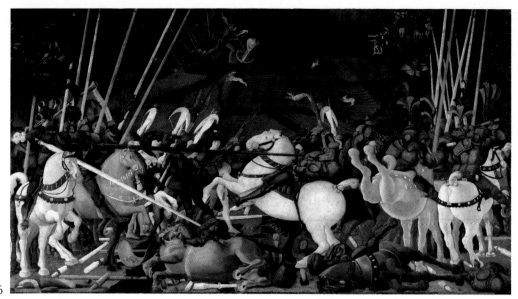

5

5. Paolo Uccello
Battle of San Romano
Florence, Uffizi

6. Paolo Uccello
*Geometrical study
of a vase*
Florence, Uffizi

6

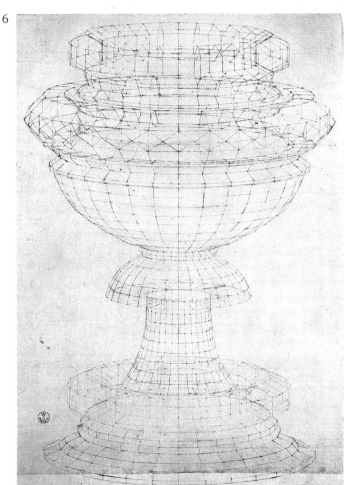

opment of the time, it will be enough to have a look at Veneziano's works dating from just after 1440, like the large altarpiece for the church of Santa Lucia de' Magnoli, now at the Uffizi. If we examine this painting, Veneziano's masterpiece, in comparison with his early works, painted probably before 1438, such as the fresco of Canto de' Carnesecchi or the *Madonna and Child* now in Bucharest, it will be obvious that his development was parallel to that of his young assistant. The altarpiece of Santa Lucia de' Magnoli is the Florentine painting that comes closest to the art of Piero. The compositional harmony between architecture and figures, achieved by following Alberti's theories, can be considered a prototype for so many of Piero's later works. Thanks primarily to the bright colours (as if the scene were taking place at midday), the artist places his figures in a realistic space, and makes them move in a graceful and balanced way. A very 'ornate' painting, in other words rich in colour, grace and texture, compared to the art of Masaccio, but which is nonetheless a logical development of the great message proposed by the Carmine frescoes.

7

The first work of Piero della Francesca's that we know probably belongs to this Florentine period: the *Madonna and Child* formerly in the Contini-Bonacossi Collection. The painting is unfortunately in very bad condition, but it is still clearly related to the work of Veneziano, so much so that it would seem likely that it was painted while Piero was in his workshop. Here the young artist already shows his interest in the study of perspective, with the Virgin fitting into the window frame. The open window replaces Veneziano's more usual background of rose bowers. Even the reverse side of the painting is of interest: within a square frame there is a monochrome vase with a simplified geometrical structure, which creates the effect of a wooden intarsia.

The relationship between Piero and the more exper-

comparable only to Masaccio's frescoes in the Brancacci Chapel or his *Sagra* among the paintings of the period. At the time it must have been the most modern synthesis between the new perspective theories elaborated in Florence and the Gothic tradition of use of colour, represented in those years by painters such as Fra Angelico and Masolino, who were anything but old-fashioned. To understand fully what the frescoes of Sant'Egidio must have meant to the artistic devel-

6

imental wood inlayers of the time will develop greatly in later years, as we shall see. Looking at this vase, we must bear in mind that in the 15th century perspective and intarsia witnessed a parallel development, and that it was in 1436 that work began on the intarsia in the Sacristy in Florence Cathedral where Brunelleschi's influence is very clear.

7. *Domenico Veneziano*
Altarpiece of Santa Lucia de' Magnoli
Florence, Uffizi

7

Piero's Early Works in Borgo San Sepolcro

In the early 1440s Piero returned to Borgo San Sepolcro, where he was recorded as town councillor in 1442. His first important commission dates from this period: the *Baptism of Christ*, now in the National Gallery in London, originally painted for the Chapel of San Giovanni in the Pieve. The most striking feature of this painting is the extraordinary lighting from above, creating delicate pastel colours, with pale shadows that surround the figures and enhance their three-dimensionality. At the centre, the figure of Christ is portrayed as a simple man, but his stance is so solemn as to make him look as majestic as a Greek god. His torso and his legs are circular and solid, like the tree on the left; the holy dove, like a little cloud, fits into a patch of sky amidst the foliage of the tree, rendered with almost Impressionistic strokes. Piero displays great originality in his interpretation of nature, reproducing its elements in simple and perfect shapes, as can be seen also in the small triangle of water that is the river Jordan, rather like a mirror reflecting the sky and the hills of the background. The formative years spent in Florence are still very evident, yet Piero succeeds already in this first work in going beyond them. The three angels on the left, with their pale but round faces, are reminiscent of the groups of children sculpted by Luca della Robbia for the Cantoria in Florence Cathedral (1432-38); and even their blonde hair, decorated with garlands, is clearly inspired by Luca's models. The face of the angel in the centre, with his

fixed gaze, brings to mind the *Madonna* painted in the mid-1430s by Domenico Veneziano for Canto de' Carnesecchi, today in the National Gallery in London. By using Veneziano's paintings of the 1430s as models, Piero seems to go back even further: the soft range of colours is very similar to Masolino's art. But the delicate, almost Gothic, textures of this group of angels are given such solidity and weight that they acquire the power of a sculptural group. In the same way, Veneziano's new techniques of drawing are clearly evident in the tense pose of John the Baptist and in the elegant figure in the background removing his clothes; but Piero had made the outlining of the figures invisible, as it is in reality, and it serves solely to delimit the patches of colour which, in the different light areas, give the bodies their depth.

In 1445 the Compagnia della Misericordia, a confraternity of Borgo San Sepolcro, commissioned Piero della Francesca to paint a polyptych for them, within three years; according to the taste of the time, the polyptych was to be painted with precious colours and have a solid gold background. Piero did not respect the time limits set down in the contract, for he was busy working on other, more important projects. The polyptych for the Misericordia was only finished after 1460, almost twenty years later. The oldest parts of the polyptych are undoubtedly the two panels with *St Sebastian* and *St John the Baptist*, to the left of the main panel. No other figure of Piero's, more than this

8

9

10

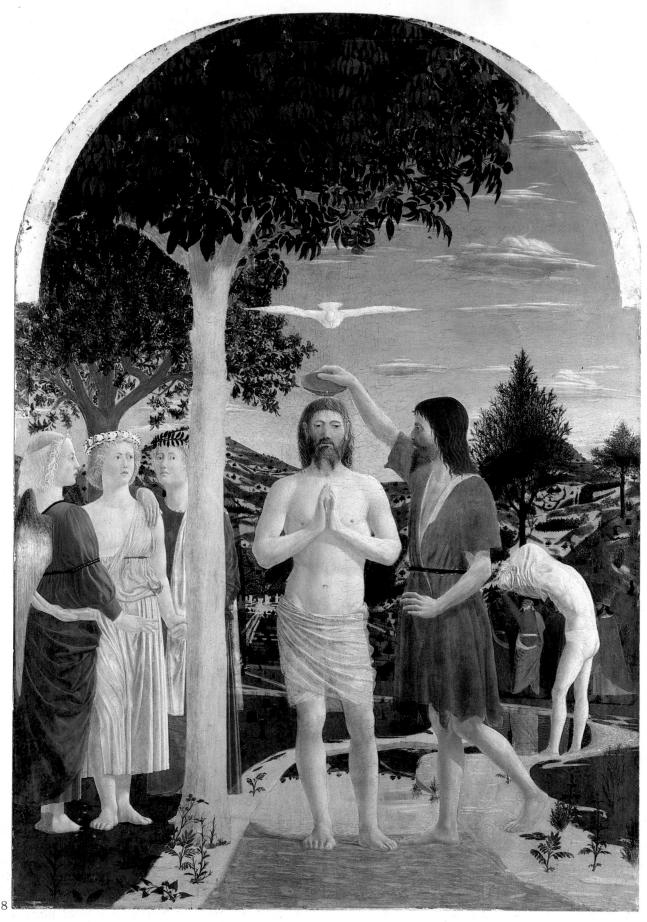

8

8. *Baptism of Christ*
167 x 116 cm
London, National Gallery

9. *Polyptych of the Misericordia*
273 x 323 cm
Sansepolcro, Museo Civico

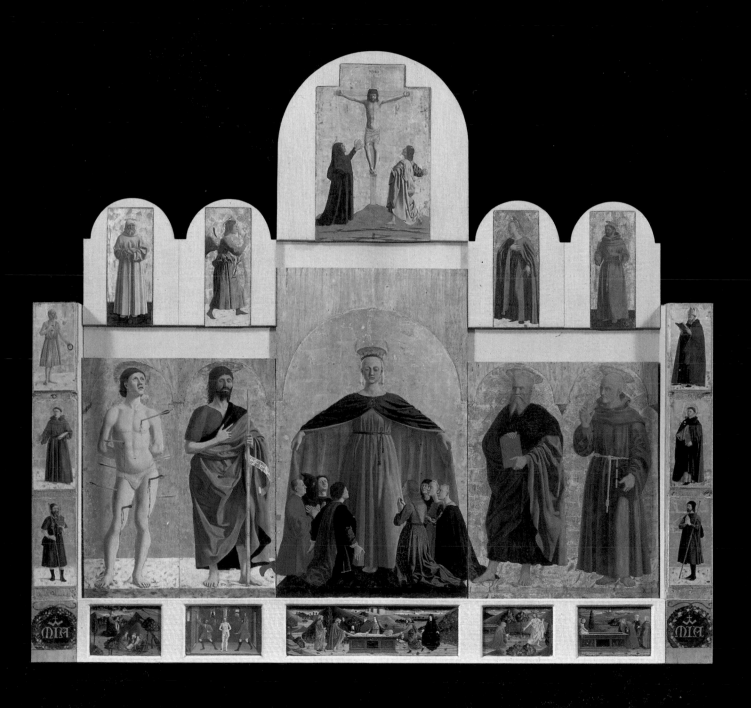

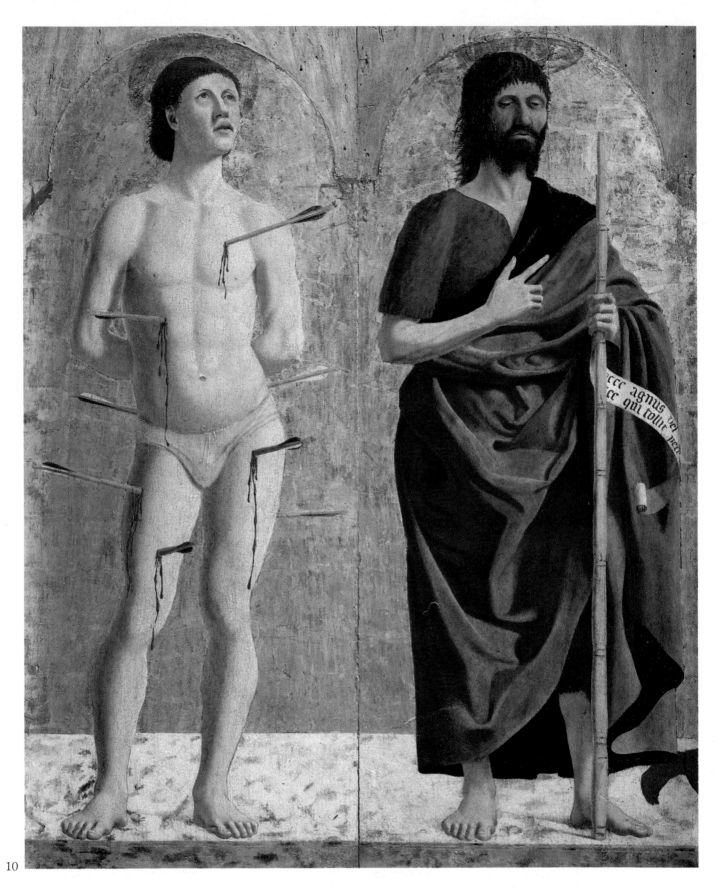

10

10-11. *Polyptych of the Misericordia*
detail of St Sebastian and St John the Baptist
108 x 90 cm
detail of the Crucifixion
81 x 52 cm
Sansepolcro, Museo Civico

12. *Masaccio*
Crucifixion
Naples, Museo di Capodimonte

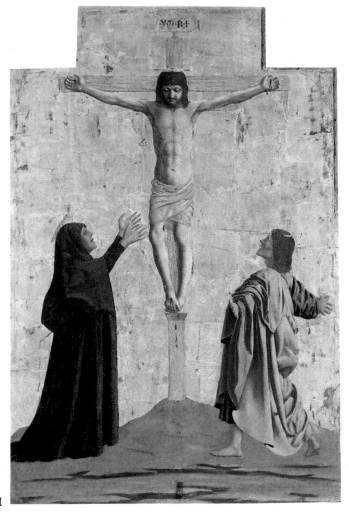

11

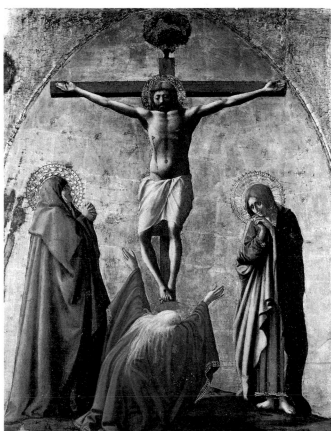

12

St Sebastian, shows such close connection with Masaccio's nudes, even in his rather graceless but realistic pose. Before Piero, only Masaccio had over succeeded in creating a real space against the flat and abstract gold gold background, in which to place flesh and blood figures.

Piero goes even further: he foreshortens the saints' feet, as though burdened by the weight of the body, and places them on pedestals creating delicate shadows. A little later Piero painted the panels of the tympanum, with the *Crucifixion* in the centre and *St Benedict*, the *Angel* and the *Madonna of the Annunciation*, and *St Francis* at the sides. The *Crucifixion* reveals the influence of Masaccio's polyptych for San Francesco in Pisa. But Masaccio created a dramatic atmosphere both with the moving gestures of the characters and with the strong, almost violent, colours; Piero's composition, on the other hand, is orderly and symmetric and the gestures of the figures are solemn, almost ritualistic.

Even the strongest and most painful emotions appear to be overruled in Piero's art by a predetermined order, controlled by a sense of balance imposed from above. This sensation of great solemnity and order is the result of the complete absence of movement that characterizes Piero's work. Piero reproduces even the most dramatic action as though fixed at its culminating moment, in its absolute expression, placed in a unitary and scientifically constructed space, where there is no room for chance or for the changing movement of things.

The *Angel of the Annunciation* is similar to Fra Angelico's celestial beings, but it is as though a strong and heavy body contributed to making that model more alive and concrete. The *Virgin of the Annunciation*, with her billowing cloak, is depicted in an attitude of very realistic and anything but divine astonishment; her feet, barely visible under the cloak, help create the two planes on which she stands. During this period Piero was assisted by another painter who is responsible for the predella and for the six figures on the side pilasters: not an excellent artist, of obviously Florentine formation, who struggled to imitate Piero's style.

As we have mentioned above, Piero completed the polyptych much later than contracted. In January 1455 the confraternity of the Misericordia threatened to demand their money back from the artist's father unless the painting were completed within forty days. Towards 1450 Piero finished the figures of *St Andrew* and *St Bernardino*; the latter is given a round and smooth halo like a saint, instead of the small halo with rays that symbolized the blessed. This indicates that the painting cannot date from before 1450, the year Bernardino was canonized.

Even in the portrayal of this saint, usually represented as an emaciated old man by traditional Sienese painters, Piero does not abandon his ideal of a strong

11 12 14 13

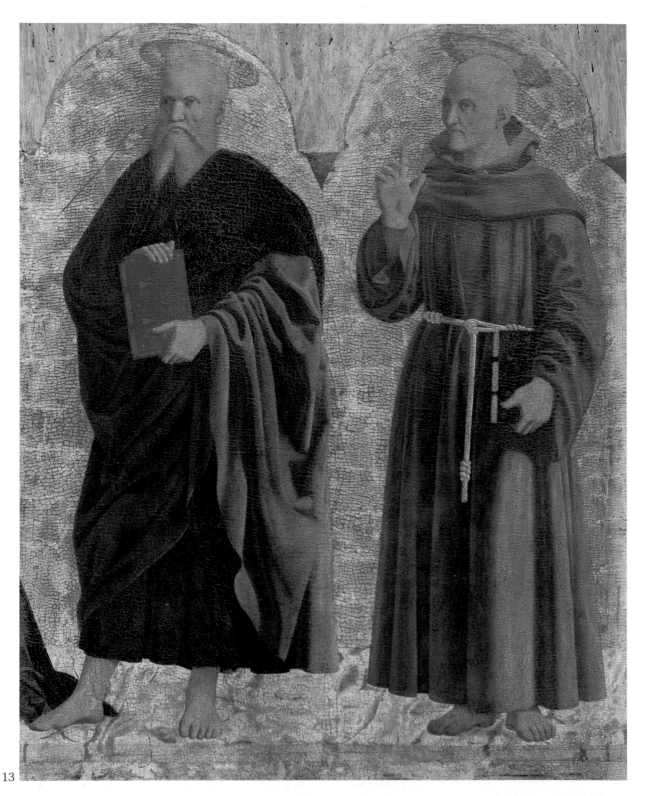

13

14

12

and solid body. Bernardino stands erect, emphasizing the spatial depth with a calm gesture of the hand. *St Andrew*, like *St John*, is clad in a flowing cloak with deep folds, creating the effect of a painted statue.

*13. Polyptych of the Misericordia
detail of St Andrew and St Bernardino
108 x 90 cm
Sansepolcro, Museo Civico*

*14. Polyptych of the Misericordia
detail of the predella with the Deposition
23 x 70 cm
Sansepolcro, Museo Civico*

*15. St Jerome and a donor
40 x 42 cm
Venice, Gallerie dell'Accademia*

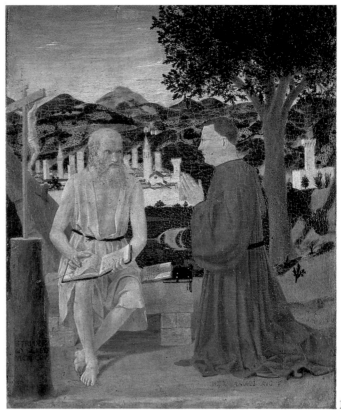
15

The Journey to Romagna: Piero's First Contact with Alberti's Architecture

While working on the Misericordia polyptych, in the late 1440s and early 1450s, Piero travelled to the Marches and to Emilia-Romagna. These journeys are documented by relatively reliable sources such as Pacioli and Vasari, by the traces of his influence on local painting and by one signed and dated painting. There is no reason to doubt Piero's presence in Pesaro and Ancona, even though nothing remains of the fresco of the *Marriage of the Virgin* in the church of San Ciriaco in Ancona, mentioned by Vasari. On the other hand, Piero's influence is unmistakeable in the fresco of the *Madonna with Saints Nicholas of Tolentino and Anthony Abbot*, painted by the painter from Camerino Girolamo di Giovanni in 1449, now in the Pinacoteca in Camerino.

Piero's presence in the major artistic centres of the Marches just before 1450 would explain the development of new perspective elements in much of the painting of this region around that period.

According to Vasari's reconstruction, it would appear that Piero della Francesca, by that time already quite famous, was called to Ferrara by the Duke of that city, Lionello d'Este. Here, too, however, we have no trace of any works painted by Piero in Ferrara, although the sources do mention a cycle of frescoes in the church of Sant'Agostino and another in Duke Borso's palace, which have since been destroyed. In any case, the most concrete evidence of Piero's presence in Ferrara certainly lies in the strong influence of his art on later Ferrarese painting.

In 1451 the artist was in Rimini, where he signed and dated the fresco of *St. Sigismund and Sigismondo Malatesta* in the church of San Francesco. But before that he had painted two small panels: *St Jerome and a* 15 *donor*, in the Gallerie dell'Accademia in Venice, and the *Penance of St Jerome*, in the Gemäldegalerie Dahlem in Berlin. We do not know exactly when or for whom these were painted, but they are probably to be included amongst the 'many paintings of small figures' mentioned by Vasari as being commissioned by several rulers during the artist's journeys in the Marches and Emilia-Romagna.

In the small panel in Venice we can see for the first time Piero's signature, on the tree trunk that forms the base of the Crucifix in the lefthand corner. On the ground, in the foreground, there is also an inscription indicating that the panel was commissioned by Gerolamo Amadi 'veneziano,' who is shown kneeling in prayer before the saint. The donor and his protecting saint appear to be conversing as equals, for it was ob-

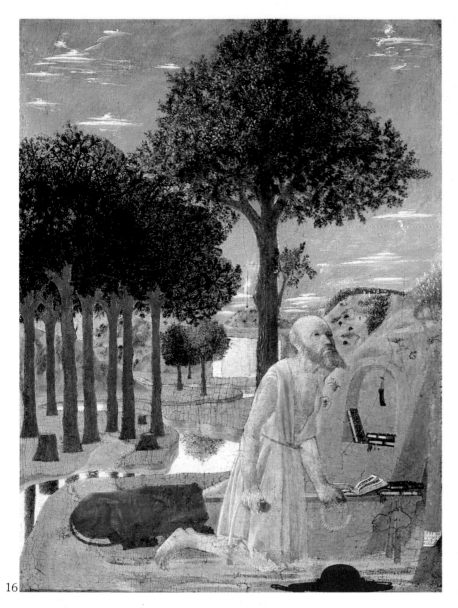

16

16. *Penance of St Jerome*
51 x 38 cm
Berlin, Gemäldegalerie Dahlem

17. *St Sigismund and Sigismondo Malatesta*
257 x 345 cm
Rimini, San Francesco (Tempio Malatestiano)

18. *St Sigismund and Sigismondo Malatesta*
detail of St Sigismund
Rimini, San Francesco (Tempio Malatestiano)

viously Piero's intention to exalt the human dignity of his patron, as he was to do again in the case of Sigismondo Malatesta in Rimini. The bright hues of colour are similar to the clear sunlit atmosphere of the London *Baptism of Christ*, and even the background, with its rolling hills and steep country paths, confirms a vision of landscape that was first anticipated in the London painting. Compared to Paolo Uccello's nighttime, rather abstract and fairytale landscapes, or Fra Angelico's gentle and precious ones, Piero's are closer to Veneziano's, or even Masaccio's, with bare hills, partially covered with vegetation. And Piero makes his landscapes even more real and alive, for the vegetation is burnt out by a Mediterranean sun, the city walls are made of white lime and the water of the river is transparent.

16 The Berlin *St Jerome* is one of the two paintings by Piero that is dated; the landscape composition is even more closely connected to the London *Baptism of Christ*. Recently this panel has been restored, and all the later additions have been removed from the back-

ground and the sky: it is as though we now had a new and hitherto unknown painting by Piero. We can now see, in the crystal-clear lighting, behind the hermit saint, a receding background with the perfectly straight tree trunks reflected in the winding river. The clear sky is barely dotted with little white pointed clouds, finer and smaller than in the *Baptism*. It may seem strange that this painting, so lacking in colour (to the extent that it was added by others not long afterwards) and basically so similar to Piero's earliest works, is dated 1450. Yet the incredible attention to detail shown by the artist in his depiction of the foreshortened books, for example, or the houses and villages painted in the background between the slender trees, clearly show the development Piero's art had undergone during his journey to Ferrara.

We know that Lionello d'Este possessed a triptych by Rogier van der Weyden before 1449, and surely the presence in Ferrara of this Netherlandish painting must have aroused Piero's interest immediately. After 1450, Piero's panel paintings begin to show a new fea-

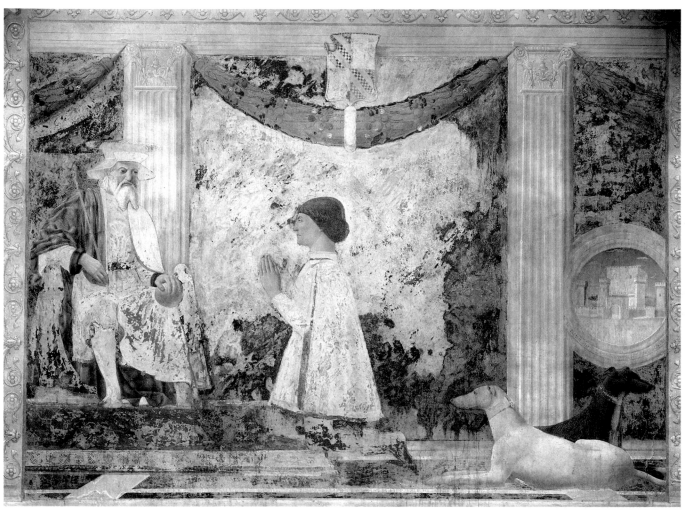

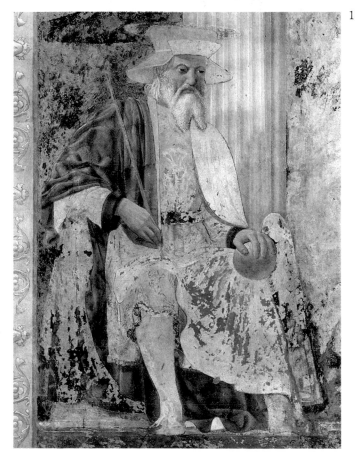

ture of his pictorial vision which will gradually develop into the extreme attention to even the tiniest details—a feature of the artist's mature work.

And so we come to 1451, the year in which Piero **17** painted the fresco of *St Sigismund and Sigismondo Malatesta* in the church of San Francesco in Rimini. With its monumental composition and the studied placing of the figures within the environment, it is the painting that most resembles the cycle in the church of San Francesco in Arezzo. In few other works of Piero's is Alberti's influence so evident, and in fact Alberti was working at the same time in the same church in Rimini, which he was transforming into the Tempio Malatestiano. The scene is enclosed by an architectural frame, reminiscent of bas-relief decorations, and is seen as though from an 'open window, through which I can see what will be painted here,' as Alberti describes the best point of view for a pictorial composition. Also influenced by Alberti is the decoration of the room with slabs of coloured marble; and Piero's interiors in later paintings all use the same decoration, en- **18** riching the colours even further. St Sigismund sits on a throne like a majestic and wise sovereign; he is depicted from below so as to make his appearance more monumental. At his feet, Sigismondo Malatesta, seen

15

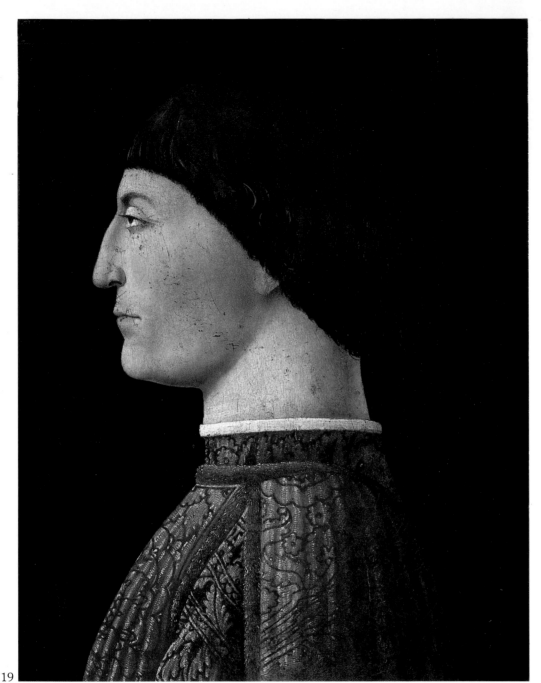

19

in profile, pays homage to his patron saint. A profane atmosphere is created by the ostentation of the symbols of temporal power: the heraldic portrait, the coat-of-arms and the castle that is visible in the distance through the small round window, like the engraving on a medallion. The pair of greyhounds, lying on the ground behind Sigismondo, is portrayed with magnificent simplicity: their intelligent expressions reveal an attentive study of nature—like a Pisanello drawing—while the roundness of their bodies confirms once more the artist's interest in the study of three-dimensionality.

19 Also dating from Piero's period in Rimini is the portrait of *Sigismondo Malatesta*, today in the Louvre. As in the case of the portrait in the fresco in the church of San Francesco, this portrait is also taken from a medal made by Pisanello in 1445 for Sigismondo. Yet, even though he was working within a context of traditional International Gothic iconography, Piero succeeds in giving it new depth: what was just an emblem on a coin becomes a fully-rounded, almost sculptural portrait, with a proud expression of unrelenting cruelty. The three-dimensional effect is achieved also by a most realistic skin tonality, created with the technique of oil paints.

Piero della Francesca's brief period spent in Romagna is of fundamental importance not only for the development of an exceptional school of painters like the Ferrarese, as we have mentioned above, but also for the gradual spreading of the study of perspective to

20

other cities in Emilia and the Po Valley, dominated until the second half of the century by a pictorial style that was still basically late Gothic. Luca Pacioli claims that Piero spent some time in Bologna, although this is not documented. But there were two artists active in Modena who were closely connected to Piero, as well as being his friends: the wood inlayers Cristoforo and Lorenzo Lendinara. It is thanks to their ability in reproducing Piero's ideas on perspective in wood that we now have the choirstalls of Modena Cathedral. Here we can see how the technique of intarsia, placing different coloured woods next to each other, is the perfect medium for the reproduction of different planes seen in perspective. In Emilia, the innovations brought by Piero only really take hold in the 1460s, but they are still present in the work of the Modenese brothers Agnolo and Bartolomeo degli Erri, of Marco Zoppo in his large polyptych for the Collegio di Spagna in Bologna, and even in the unique *Pietà* by Bartolomeo Bonascia, now in the gallery in Modena.

20

Before returning to Borgo San Sepolcro in 1453, Piero must have stopped in Urbino. It is almost certainly during this first visit to Urbino that Piero painted one of his most famous panel paintings: the *Flagellation* now in the National Gallery in Urbino. This painting contains subtle references to the situation of the time, which are very difficult for us to understand today.

21

From the point of view of composition and perspective it is very rigorously planned. His interest in spatial depth, which had been evident from his earliest works, is here developed to such an extent as to suggest that Piero had already embarked on theoretical studies as well. The composition appears to be divided into two scenes, separated by the column supporting the temple in which the Flagellation of Christ is taking place. On the right are three figures, arranged in a semi-circle; their identity is not certain. They are probably well-known characters of the time and, as such, they would be portrayed with their real features. The

22

importance of the architecture in this painting, with the elegant classical temple, would suggest again that Piero was in touch with Alberti's contemporary writings. During the 15th century every great painter interested in perspective appears to have had an architect whose work on the measuring of volumes and space he studied. Just as Masaccio's concept of space would be inconceivable to us without Brunelleschi's architecture, if it were not for Alberti's work we would not be able to understand Piero's scientific methods of arranging his figures within his compositions. The onlooker must stand directly in the centre of the painting, for the composition is strictly unitarian, and this unity is achieved by the rigorous use of a single vanishing point. The organization of space in 14th-century art, even in Giotto's paintings, was fragmentary and the laws of perspective were only hinted at, for there was not a single vanishing point. The Urbino *Flagellation* is the ultimate example of Quattrocento linear perspective. And yet there is nothing aridly theoretical about this painting. The distance between the figures is suggested by the reflection of light on the pure colours, by the crystal-clear atmosphere of the morning light. A clear light surrounds the figures in the background, watching the Flagellation, with effects that anticipate Venetian painting from Antonello da Messina to Giovanni Bellini. Even though he is working within a unitary space, Piero does not give up his interest in detail, such as the ceiling of the temple or the bronze sculpture on the column with its splendid reflection of the light. These effects are obtained by a subtle technique, certainly deriving from Piero's acquaintance with Netherlandish paintings, like the Van Eyck that belonged to the Duke of Urbino (now lost); but his style is so original that his sources are barely recognizable. Even the magnificent damask garment worn by the character on the far right, with its contrast between blue and gold, reveals Piero's love for luxurious clothing and for the most fashionable styles, which many Florentine painters, following Masaccio's austere example, had eliminated entirely from their work. This is another element that Piero had acquired from the late Gothic tradition and which he had also found in the latest paintings by Netherlandish artists, where the brightness of the coloured fabrics was further enhanced and given a velvet-like softness by the use of oil paints.

We mentioned earlier the difficulty of interpreting the more hidden meaning of the painting. In recent years, the theory that seems to be proposed most frequently is that the painting was commissioned as an attempt to favour the reconciliation between the two Christian churches, of the East and of the West, in view of the imminent Turkish attack on Constantinople. Both the presence of the character in the centre, dressed after the Greek fashion, and the in-

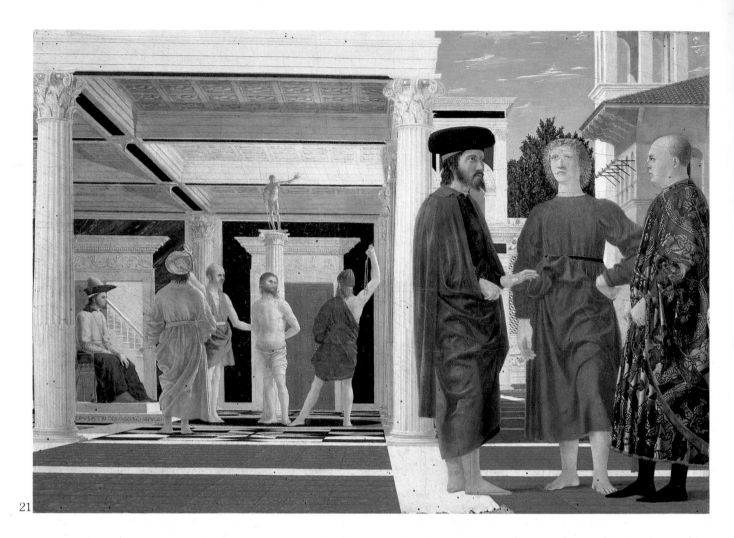

21

scription 'convenerunt in unum' which could be read on the frame until the last century, would seem to support this interpretation. But, as in the case of many other paintings commissioned by patrons who were deeply involved in the Humanist culture of the times, the meaning of these two separate yet related scenes is still to a great extent unexplained.

Piero's work in Ferrara, Rimini and Urbino stimulated the artistic development of these towns; thanks to his innovations they became artistic centres of great importance, rivalling the traditional art capitals of the time, such as Florence and Siena. Piero left Florence as soon as work on the frescoes in Sant'Egidio was finished and never returned; the Florentine trends in painting, based as they were on drawing rather than on perspective and colour, could not possibly attract him. His travels coincided several times with those of Alberti, also a Florentine but, like Piero, only as far as his basic training was concerned. The parallel development of these two artists is responsible for the spread of the great 're-born' art in Florence in the early 15th century; later it was in part rejected by the Florentine heirs of Brunelleschi and Masaccio. Piero della Francesca's painting, made up of so many complex and varied elements yet blended together in a single expression, was welcomed much more favourably in

21. Flagellation
59 x 81 cm
Urbino, Galleria Nazionale

22. Flagellation, detail
Urbino, Galleria Nazionale

the smaller centres. Here the new rulers, such as the Malatesta and the Montefeltro, who had only recently acquired their positions of power fighting in the battlefields at the head of their armies, were attempting to legitimize their fortunes, from the cultural point of view as well, by becoming the intelligent patrons of a profoundly new art.

Piero's perfect synthesis of a progressive instrument such as linear perspective, with some of the elements of the Gothic tradition and the attention to even the tiniest details derived from Netherlandish art was undoubtedly the most important artistic product created thanks to the patronage of the new rulers of Central Italy as an alternative to contemporary Florentine trends.

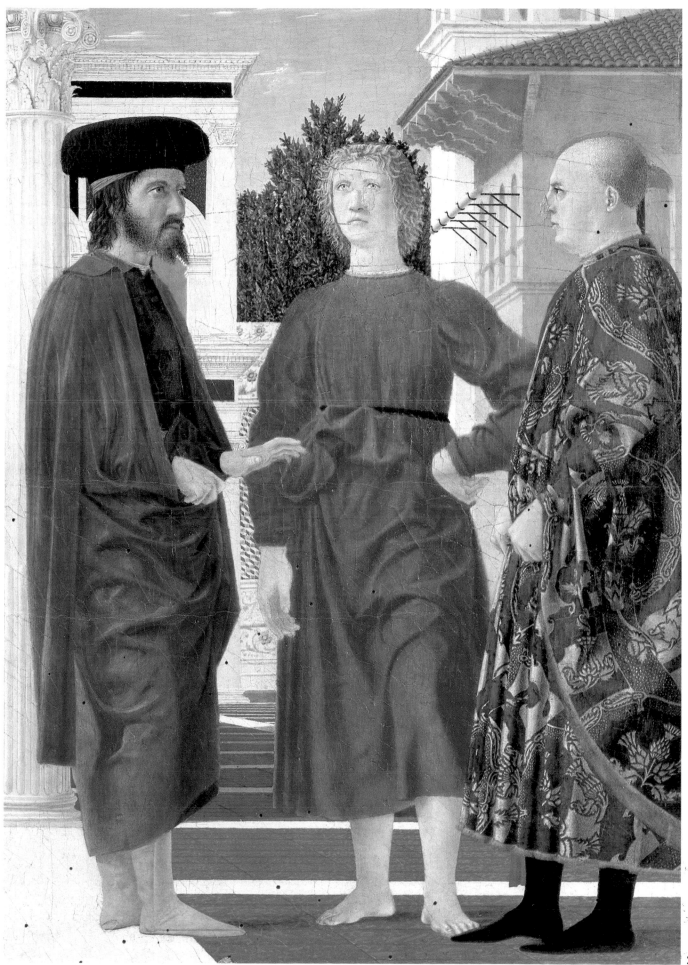

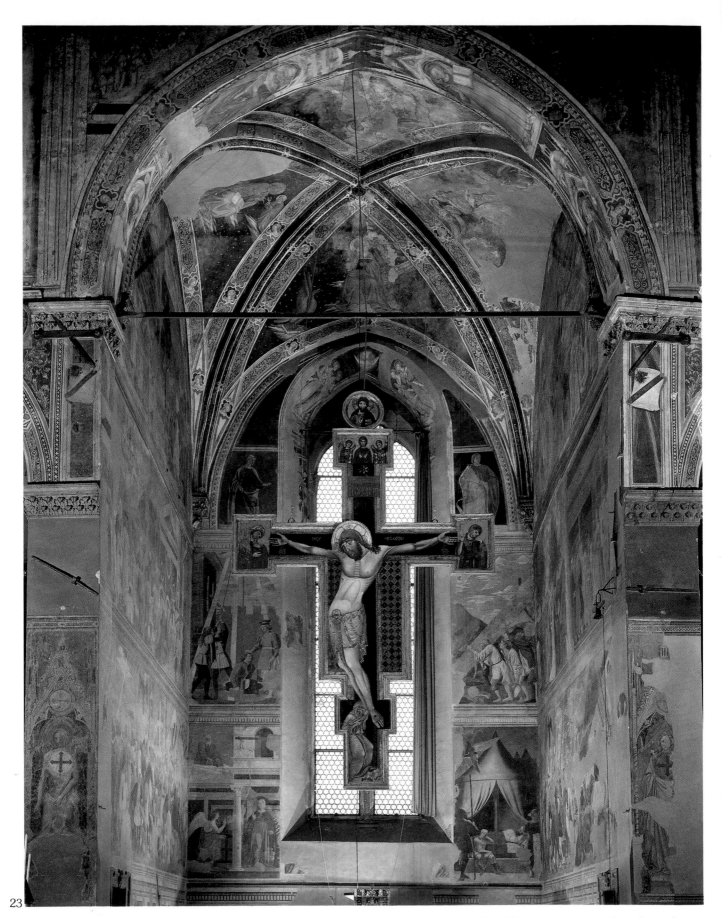

23

23. Cappella Maggiore in the church of San
Francesco, Arezzo
The 13th-century Crucifix with St Francis, formerly
attributed to Margarito d'Arezzo and now attributed
to the Maestro di San Francesco, was already in the
church when Piero della Francesca frescoed the
chapel; it has recently been placed above the main
altar.

The Fresco Cycle in the Church of San Francesco in Arezzo

In the years immediately following his travels through Romagna, Piero della Francesca is recorded in Borgo San Sepolcro (1435-55), but the artist had probably been to Arezzo several times during 1452 as well, where work on the fresco cycle in the Cappella Maggiore of the church of San Francesco had already begun. The contract awarding the commission of these famous paintings to Piero has not survived, so that we cannot be absolutely certain as to the identity of the patron nor do we know the exact chronology of the project. We know that the chapel belonged to the Bacci, a family of rich Arezzo merchants, who had had it decorated with a stained-glass window in 1417 and had planned to commission a fresco cycle. In 1447 Francesco Bacci sold a vineyard to pay the Florentine painter Bicci di Lorenzo who was working in the chapel. Bicci was one of the last representatives of the Florentine Gothic tradition; he died in 1452, leaving the decoration of the chapel barely begun, for he had only painted the vaulted ceiling and the two Doctors of the Church on the underside of the entrance arch. Piero probably began to work for the Bacci family right after Bicci's death, covering in a few years the walls of the Gothic chapel with the most modern and most advanced—in terms of perspective—frescoes that the Italian 15th century could have created.

The subject-matter of the stories illustrated by Piero is drawn from Jacopo de Voragine's *Golden Legend*, a 13th-century text that recounts the miraculous story of the wood of Christ's Cross. This popular text, typical of the medieval love for accounts of miraculous events, inspired several other fresco cycles in the 14th and 15th centuries in churches belonging to the Franciscans, an order that was in close contact with the people. The most famous iconographical precedents for Piero's stories are Agnolo Gaddi's frescoes painted for the Franciscans of Santa Croce in Florence, Cenni di Francesco's painted for the church of San Francesco in Volterra and Masolino's *Stories of the Cross* painted in 1424 in the church of Sant'Agostino in Empoli.

This traditional subject-matter was undoubtedly proposed to Piero—and probably to Bicci di Lorenzo

24. Scenes from the fresco cycle of the Cappella Maggiore in San Francesco, Arezzo
Death of Adam (25)
Exaltation of the Cross (30)
The Queen of Sheba in adoration of the Wood and the Meeting of Solomon and the Queen of Sheba (34)
Angel (38)
Angel (39)
Prophet (40)
Prophet (41)
Torture of the Jew (43)
Burial of the Wood (44)
Discovery and Proof of the True Cross (45)
Battle between Constantine and Maxentius (49)
Constantine's Dream (52)
Annunciation (53)
Battle between Heraclius and Chosroes (54)
Angel (59)

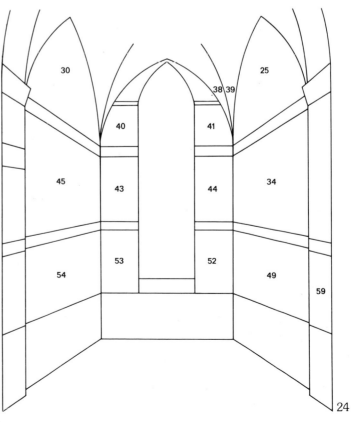

before him—by the Franciscan order of Arezzo, while some variations on the traditional account, presumably prompted by contemporary events, must have been suggested to the artist by a scholarly Humanist. Although we have no documents to prove Piero's contact with Giovanni Bacci, it has recently been suggested that this Humanist, a member of the rich family who owned the chapel, was responsible for commissioning the frescoes. If that is case, the learned Giovanni was probably also responsible for guiding Piero in choice of episodes to represent. Briefly, the story tells how Adam, on his deathbed, sends his son Seth to Archangel Michael, who gives him some seedlings from the tree of original sin to be placed in his father's mouth at the moment of his death. The tree that grows on the patriarch's grave is chopped down by King Solomon and its wood, which could not be used for anything else, is thrown across a stream to serve as a bridge. The Queen of Sheba, on her journey to see Solomon and hear his words of wisdom, is about to cross the stream, when by a miracle she learns that the Saviour will be crucified on that wood. She kneels in devout adoration. When Solomon discovers the nature of the divine message received by the Queen of Sheba, he orders that the bridge be removed and the wood, which will cause the end of the kingdom of the Jews, be buried. But the wood is found and, after a second premonitory message, becomes the instrument of the Passion. Three centuries later, just before the battle of Ponte Milvio against Maxentius, Emperor Constantine is told in a dream that he must fight in the name of the Cross to overcome his enemy. After Constantine's victory, his mother Helena travels to Jerusalem to recover the miraculous wood. No one knows where the relic of the Cross is, except a Jew called Judas, who refuses to reveal the secret. Judas is tortured in a well and finally confesses that he knows of a temple dedicated to Venus where the three crosses of Calvary are hidden. Helena orders that the temple be destroyed; the three crosses are found and the True Cross is recognized because it causes the miraculous resurrection of a dead youth. In the year 615, the Persian King Chosroes steals the wood, setting it up as an object of worship amidst idolatrous symbols. The Eastern Emperor Heraclius wages war on the Persian King and, having defeated him, returns to Jerusalem with the Holy Wood. But a divine power prevents the Emperor from making his triumphal entry into Jerusalem. So Heraclius, setting aside all pomp and magnificence, enters the city carrying the Cross in a gesture of humility, following Jesus Christ's example.

Very briefly, this is the basic narrative account of the *Story of the Cross*. It is hardly surprising that this rather naive tale was used so frequently as a source in late 14th-century Tuscan painting, especially by those painters whose work was essentially anecdotal.

At a first glance, nothing could seem more far removed from Piero's solemnly constructed compositions than this medieval and colourful folktale; nothing could have been more foreign to his sobre and classical painting than the naive atmosphere of the miracles of the *Golden Legend*. And yet we shall see how the stylistic interpretation that Piero gives these events raises the story to a level of solemnity and gravity that almost makes it an epic poem.

The first large scaffolding was probably built in 1452; it was used to reach the lunettes at the top on the two side walls, where the first two stories were painted. The first fresco, in the righthand lunette, illustrates the story of the Adamites in three separate episodes. On the right, the ancient Adam, seated on the ground and surrounded by his children, sends Seth to Archangel Michael. In the background, we see the meeting between Seth and Michael, while on the left, in the shadow of a huge tree, Adam's body is buried in the presence of his family. By placing all three stages of the story within the same background landscape, Piero is abiding by traditional narrative schemes already used by Masaccio in his fresco of the *Tribute Money* in the Brancacci Chapel. The meeting between Seth and the Archangel (which, for example, in Agnolo Gaddi's fresco had been given a prominent position) takes place in the distance, as though it were of secondary importance; in the foreground Piero has placed his splendid group of Adam's sons. These are the representatives of a new mankind, whose ideal beauty is somewhat reminiscent of certain examples of classical sculpture. But there is no feeling of a return to antiquity in Piero's paintings: his inspiration rests almost entirely on contemporary pictorial developments and he introduces a new vision of man and nature, studied, for the first time, down to the magical changing of lighting. A clear, bluish light envelops men and objects, while delicate shadows run across the bodies revealing their three-dimensionality. In these first scenes of the Arezzo cycle, in the strong sense of drawing shown in the anatomy of the figures, in the depiction of their solid yet elegant limbs, Piero's Florentine

25
26

27

28

25. *Death of Adam*
390 x 747 cm
Arezzo, San Francesco

26. *Death of Adam*
detail of Adam and his children
Arezzo, San Francesco

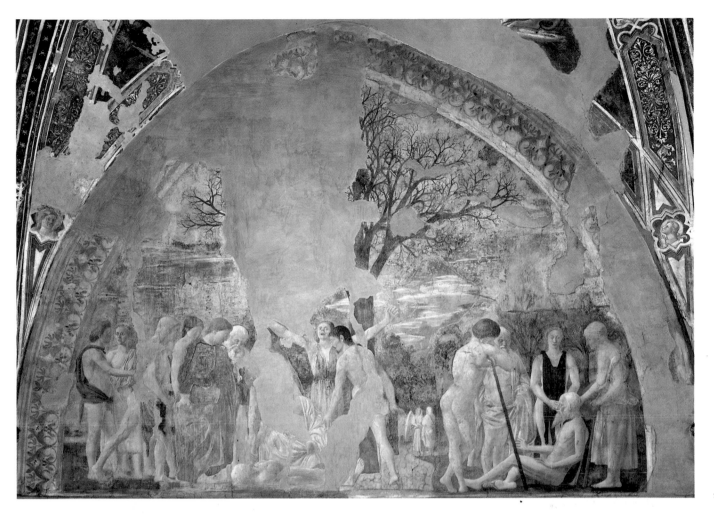

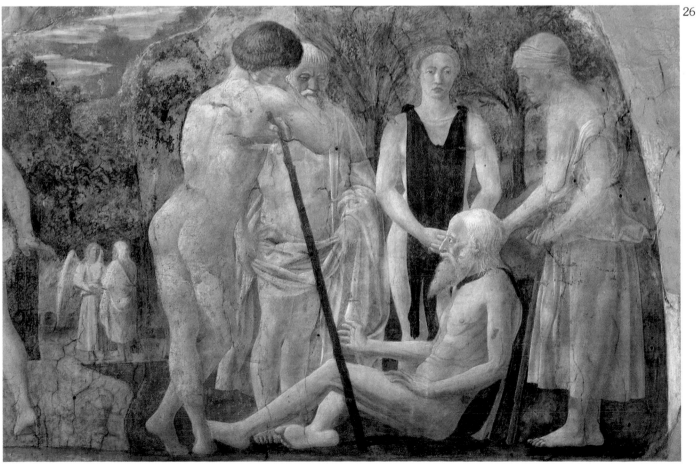

26

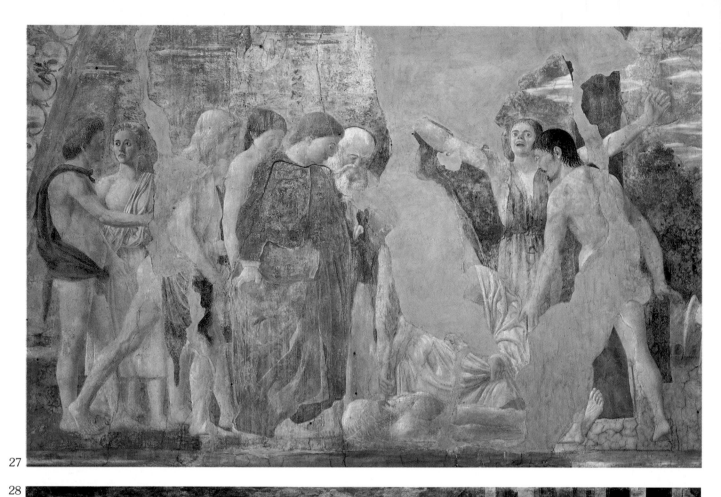

27

28

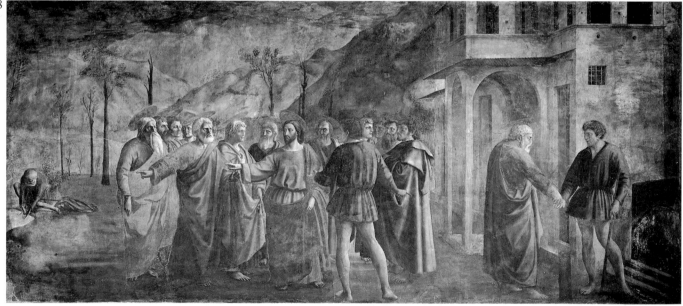

27. *Death of Adam*
detail of Adam's burial
Arezzo, San Francesco

28. *Masaccio*
Tribute Money
Florence, Santa Maria del Carmine, Brancacci Chapel

29. *Death of Adam*
detail of Adam's burial
Arezzo, San Francesco

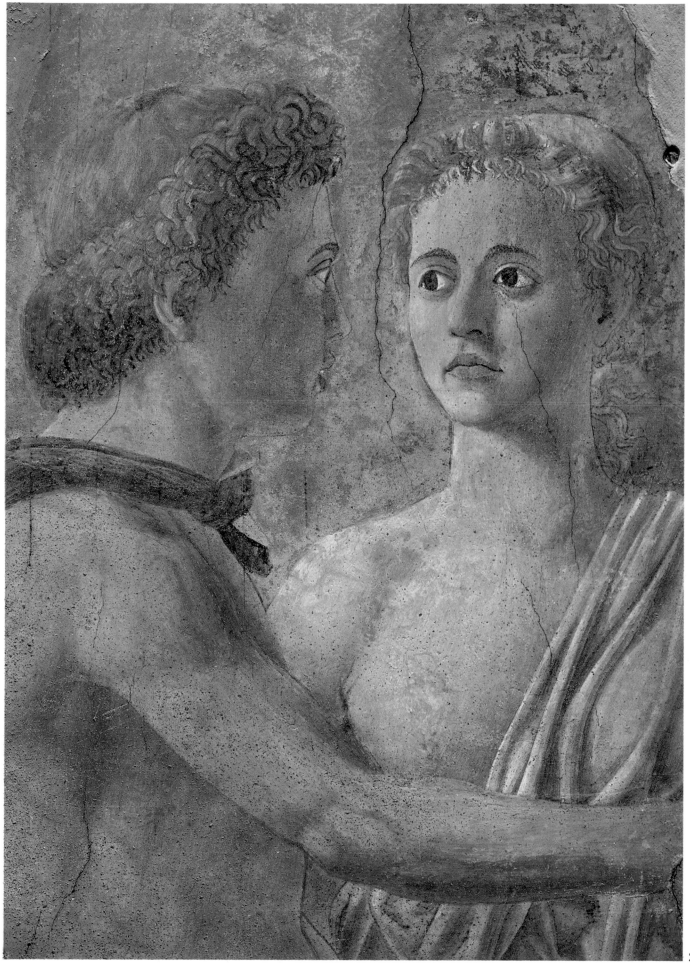

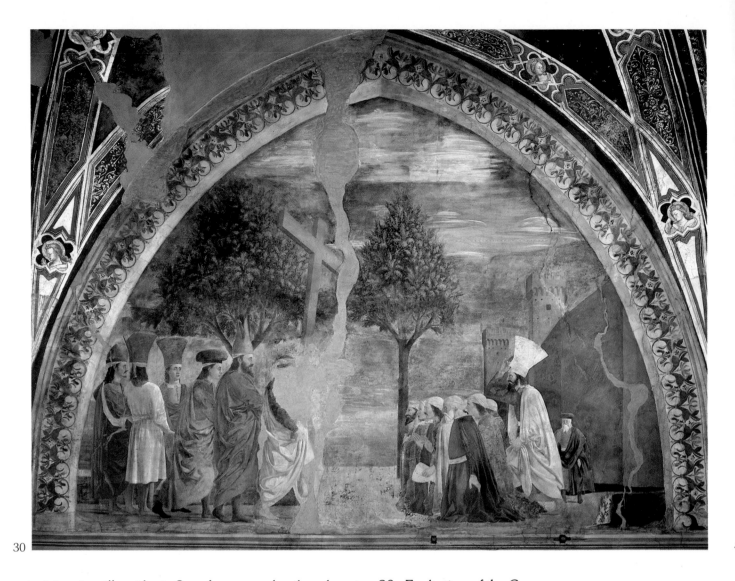

30

training is still evident. See, for example, the almost naturalistic depiction of Eve's ancient and wrinkled features, or Adam's rigid body, lying lifeless surrounded on all sides by the straight and muscular legs of his descendants. As in the *Crucifixion* of the Borgo San Sepolcro polyptych, here, too, the profound feeling of grief, masterfully expressed by the woman with outstretched arms, does not give rise to movement; everything is frozen in that fixed gesture and subordinated to the unmoving laws of perspective. As in an allegory of human life, in this fresco the young stand next to the old; the two youths on the left, who witness with dismay the first death in the history of man, are undoubtedly among the most noble and natural creations of the painting of all time.

Piero della Francesca's work continues in the lefthand lunette with the scene showing the *Exaltation of the Cross*, the last episode of the cycle. Evidence that this scene was painted just after the righthand lunette is offered by the almost reluctant modelling that Piero uses in his depiction of Heraclius's followers, marching outside the walls of Jerusalem. The figure of the Emperor himself, on the other hand, is almost entirely illegible now. The Oriental noblemen wear splendid

30. *Exaltation of the Cross*
390 x 747 cm
Arezzo, San Francesco

31. *Exaltation of the Cross, detail*
Arezzo, San Francesco

11

29

30

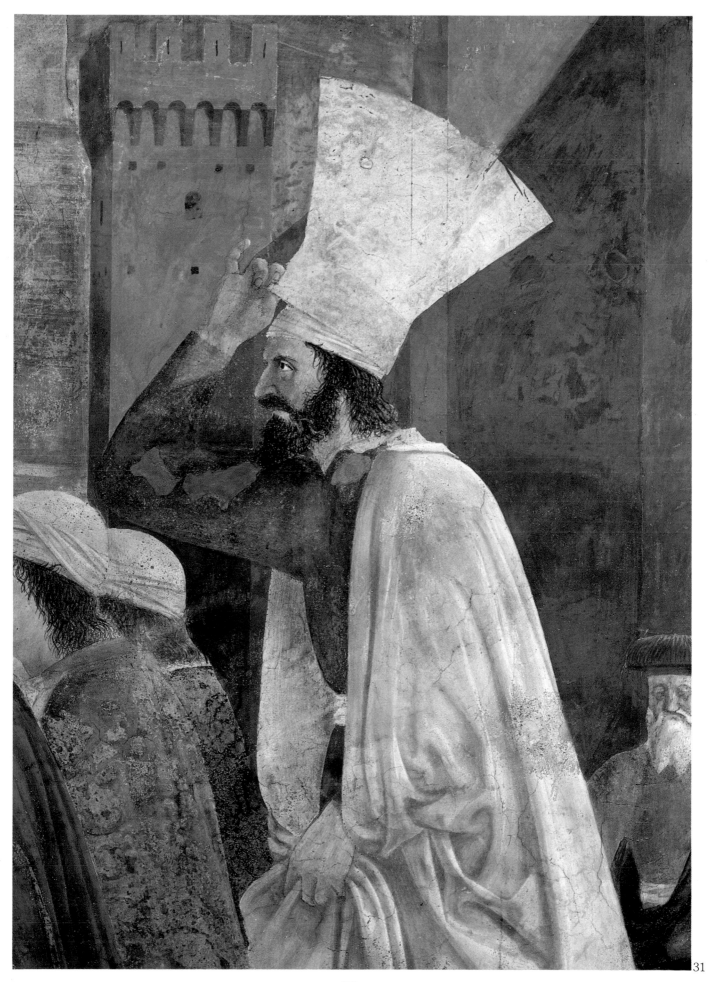

31

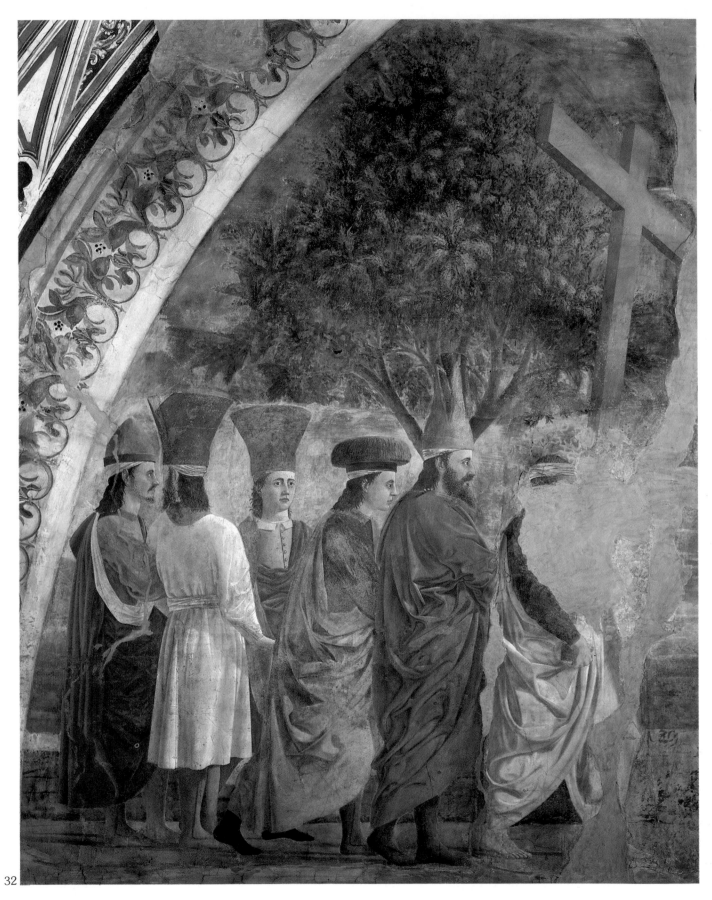

32

*32. Exaltation of the Cross
detail of Heraclius's followers
Arezzo, San Francesco*

28

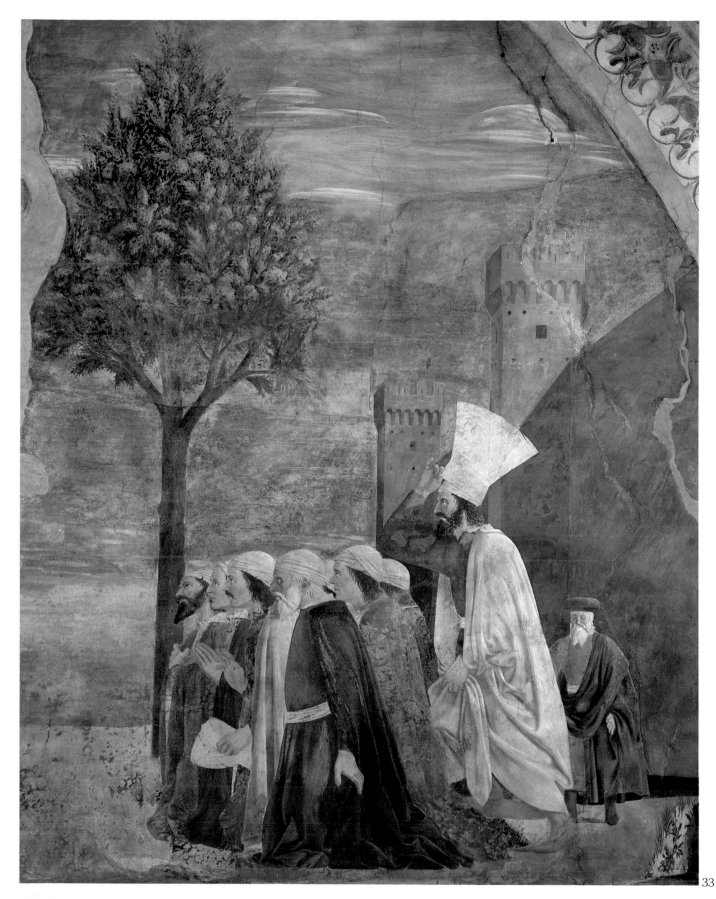

33

33. Exaltation of the Cross
detail of the inhabitants of Jerusalem in adoration
of the Cross
Arezzo, San Francesco

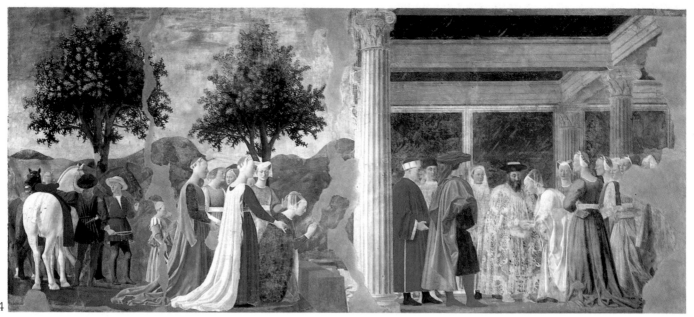

34

35

34. *The Queen of Sheba in adoration of the Wood and the Meeting of Solomon and the Queen of Sheba*
336 x 747 cm
Arezzo, San Francesco

35. *Adoration of the Holy Wood*
Arezzo, San Francesco

36. *Lorenzo Ghiberti*
Meeting of Solomon and the Queen of Sheba
Florence, Baptistry

37. *Meeting of Solomon and the Queen of Sheba*
Arezzo, San Francesco

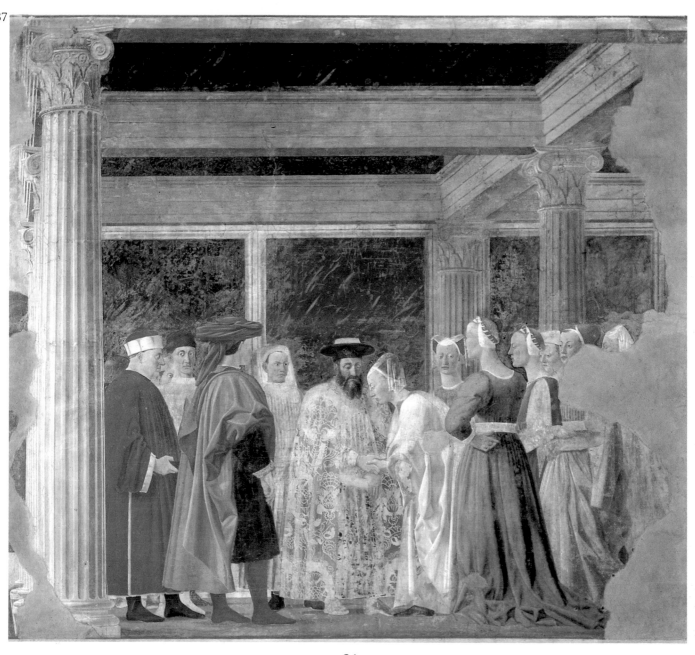

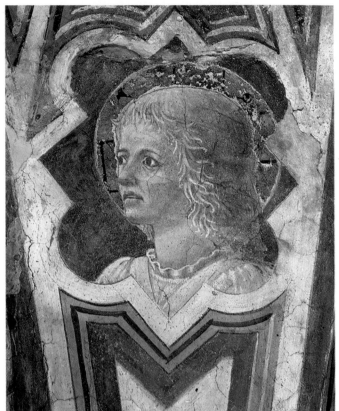

Greek headdresses, like the ones that Piero must have seen in Florence in 1439 during the 'Council of the Greeks.' The exotic elegance of those headdresses had been admired by all the Florentines at the time.

31 Piero's interest in these enormous hats, cylidrical or pyramidal in shape, is dictated by the same motives which had driven Paolo Uccello to concentrate on the complex armour of contemporary warriors—the study of shapes and perspective.

And the colours of the garments are more lively, too. In the midday light and under the blue sky, they vary from pale blue to violet, from bottle-green to pearl-white. This scene is the confirmation that Piero wishes to depict an ideal mankind, healthy and strong, with a peaceful expression, characterized by calm, measured gestures. He conveys the impression of a race of mature men, rationally at peace with themselves, far removed from the dramatic emotions of Masaccio's heroic apostles or his realistic Florentine beggars, with their menacing expressions and their abrupt, urgent gestures.

We do not know how much time after he had begun work on the cycle Piero della Francesca had the scaffolding lowered so that he could start painting the scenes directly below the lunettes. But it must have been before his journey to Rome in 1458. The two fol-
34 lowing episodes, *The Queen of Sheba in adoration of the Wood* and the *Meeting of Solomon and the Queen of Sheba*, are shown in the same fresco, separated from each other by the column of the royal palace, re-

peating the composition scheme used in the *Flagellation*. Here, too, the architectural element (the column) is the centre of the composition and the vanishing point for the whole fresco. The episode on the left, with the Queen of Sheba shown in adoration of the little bridge, is drawn from the *Golden Legend*, while the *Meeting of Solomon and the Queen of Sheba* is an 37 iconographical element added by Piero. The subject, quite rare in artistic iconography, also appears in one of the panels of Lorenzo Ghiberti's *Doors of Paradise*, 36 produced at more or less the same time for the Florence Baptistry. This scene is probably intended to suggest the meeting between Gentiles and Christians, and more particularly, in the 1450s, the hoped-for reunification of the Church of Rome with the Eastern Church, to fight against the Turks who had conquered Constantinople (1453). It seems quite likely that this addition was suggested to Piero by Giovanni Bacci, who together with his friend Ambrogio Traversari and several other Florentine Humanists had been one of the most ardent supporters of the unity of the two churches, both during and after the 1439 Council.

Behind the Queen of Sheba, kneeling in adoration, 35 is her retinue of aristocratic ladies in waiting, with their high foreheads (according to the fashion of the times) emphasizing the round shape of their heads and the cylindrical form of the neck. Their velvet cloaks softly envelop their bodies, reaching all the way to the ground. The almost perfect regularity of the composition is underlined by the two trees in the background,

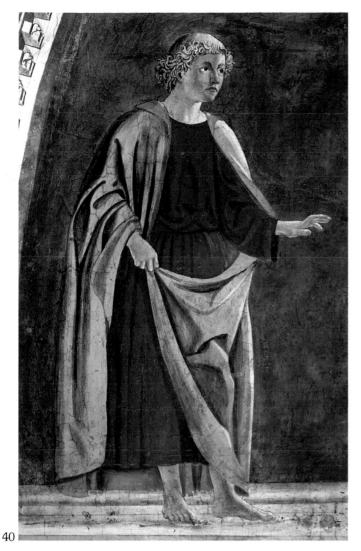

40

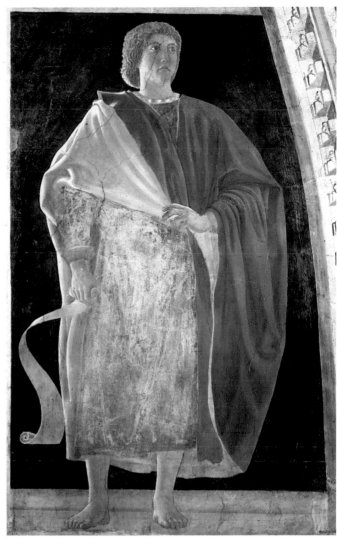

41

38. Angel
Arezzo, San Francesco

39. Angel
Arezzo, San Francesco

40. Prophet
Arezzo, San Francesco

41. Prophet
Arezzo, San Francesco

whose leaves hover like umbrellas above the two groups of the women and of the grooms holding the horses. And yet Piero's constant attention to the regularity of proportions and the construction according to perspective never gives way to artificially sophisticated compositions, schematic symmetries or anything forced. Thanks to his invention of creating two separate scenes, whose single vanishing point is placed between them, on the central column, each of the two stories gives the impression of being slightly irregular in composition. The famous scene of the *Meeting of* 37 *Solomon and the Queen of Sheba* takes place within a typically Albertian architectural structure, enlivened by decorations of coloured marble. Everything seems created according to architectural principles: even the three ladies standing behind the Queen are placed so as to form a sort of open church apse behind her. There is a real sense of spatial depth between the characters witnessing the event; and their heads, one behind the other, are placed on different planes. This distinction of spatial planes is emphasized also by the different colour tonalities, with which Piero has by this stage in his career entirely replaced his technique of

33

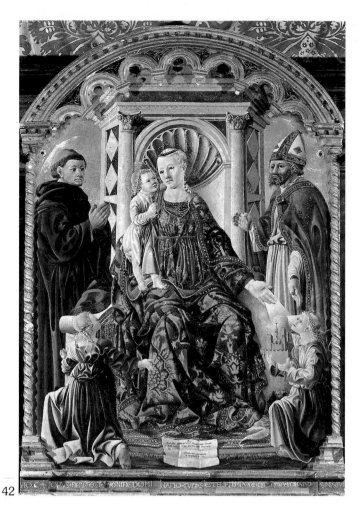

42

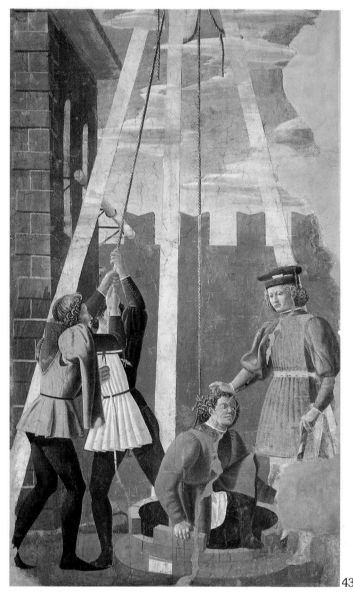

43

outlining the shapes used in previous frescoes. There is an overall feeling of solemn rituality, rather like a lay ceremony: from Solomon's priestly gravity to the ladies' aristocratic dignity. Each figure, thanks to the slightly lowered viewpoint, becomes more imposing and graceful; Piero even succeeds in making the characteristic figure of the fat courtier on the left, dressed in red, look dignified. In this fresco we truly feel that man for Piero della Francesca, as indeed for Alberti, is the 'means and measure of all things.'

Work on the fresco cycle continued on the end wall, where the size of the scenes was smaller because of
38 the space occupied by the window. Piero painted the
39 heads of angels inside the quatrefoils along the ribbing. Around the stained-glass window the artist painted two young prophets at the top, who look out like two
40 solid guardians. In the lefthand prophet one can recognize the hand of an assistant, who painted the figure following Piero's cartoon, achieving however a rather
41 arid result. The much higher quality of the righthand prophet proves that it was certainly painted by Piero himself: see, for example, the compact and luminous red drapery, or the modelling of the face with its large eyes, gazing out proudly. Also on the sides of the window, but lower down, Piero placed on the left the *Burial of the Wood* and on the right the *Torture of the*

42. Giovanni da Piamonte
Madonna delle Grazie
Città di Castello, Santa Maria delle Grazie

43. *Torture of the Jew*
356 x 193 cm
Arezzo, San Francesco

44. *Burial of the Wood*
356 x 190 cm
Arezzo, San Francesco

Jew. These two stories were painted by Piero's main assistant, the Florentine Giovanni da Piamonte, whose only other certain work is the panel of the *Madonna delle Grazie* in the church of the same name in Città di Castello (1456). He was an artist of considerable talent who managed to follow Piero's style remarkably well in the frescoes in Arezzo, executing the cartoons designed by the master. His heavier hand gives the figures a more 'peasant' look, with pronounced features, fleshy lips, almost Negroid, as in the figure of Judas in the *Torture*. In this fresco, despite the dramatic nature of the subject, which should give rise to a great sense of movement, once again we find the contrary. Piero's world is governed by measured perspective, eliminating all unplanned movement. If we forget for a moment the subject of the story, the scene could appear to be taking place in a peaceful princely court.

In the *Burial of the Wood*, Giovanni da Piamonte's heavy modelling draws the stiff folds of the bearers' garments and their hair, rather mechanically tied in bunches. On the Cross the vein of the wood, like an elegant decorative element, forms a halo above the head of the first bearer, who thus appears as a prefiguration of Christ on the way to Calvary. The sky covers half the surface of the fresco and the irregular white clouds are as though inlaid in the expanse of blue.

On the wall opposite the *Meeting of Solomon and the Queen of Sheba* is the large scene of the *Discovery and Proof of the True Cross*, one of Piero's most complex and monumental compositions. The artist depicts on the left the discovery of the three crosses in a ploughed field, outside the walls of the city of Jerusalem, while on the right, taking place in a street in the city, is the *Proof of the True Cross*. His great genius which enables him to draw inspiration from the simple world of the countryside, from the sophisticated courtly atmosphere, as well as from the urban structure of cities like Florence or Arezzo, reaches in this fresco the height of its visual variety. The scene on the left is portrayed as a scene of work in the fields, and his interpretation of man's labours as acts of epic heroism is further emphasized by the figures' solemn gestures, immobilized in their ritual toil.

At the edge of the hills, bathed in a soft afternoon light, Piero has depicted the city of Jerusalem. It is in fact one of the most unforgettable views of Arezzo, enclosed by its walls and embellished by its varied coloured buildings, from stone grey to brick red. This sense of colour, which enabled Piero to convey the different textures of materials, with his use of different tonalities intended to distinguish between seasons and times of day, reaches its height in these frescoes in Arezzo, confirming the break away from contemporary Florentine painting. To the right, below the temple to Minerva, whose facade in marble of various colours

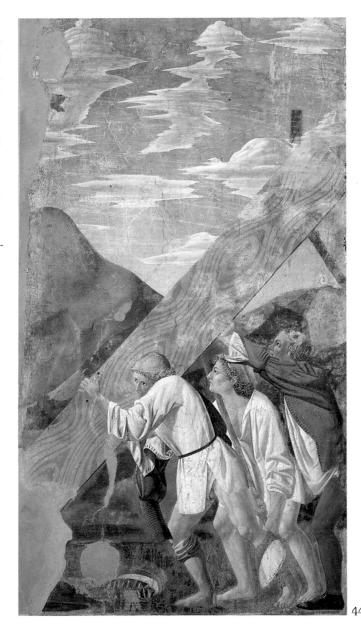

44

is so similar to buildings designed by Alberti, Empress Helena and her retinue stand around the stretcher where the dead youth lies; suddenly, touched by the Sacred Wood, he is resurrected. The sloping Cross, the foreshortened bust of the youth with his barely visible profile, the semi-circle created by the Helena's ladies-in-waiting, and even the shadows projecting on the ground—every single element is carefully studied in order to build a depth of space which, never before in the history of painting, had been rendered with such strict three-dimensionality.

Between 1458 and 1459, during the papacy of Pius II, Piero della Francesca is recorded in Rome. The Arezzo fresco cycle was probably completed on his return to Tuscany. The last stories painted by Piero on the walls of the Bacci Chapel, while still fitting into the stylistic unity of the whole, display an even greater sense of light and colour, suggesting that the artist had further developed his techniques in the field. Many Spanish and Netherlandish artists had spent time in

35

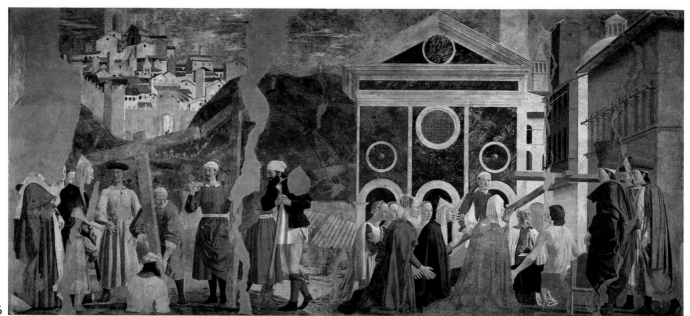

45

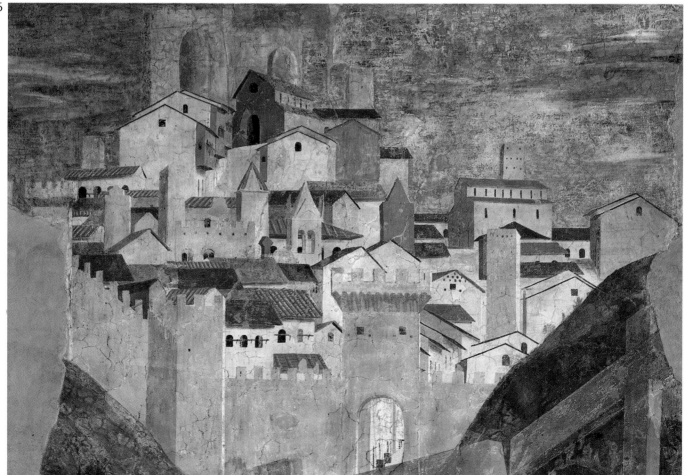

46

45. *Discovery and Proof of the True Cross*
356 x 747 cm
Arezzo, San Francesco

46. *Discovery of the True Cross*
detail of the city of Jerusalem (view of Arezzo)
Arezzo, San Francesco

47. *Discovery of the True Cross*
Arezzo, San Francesco

48. *Proof of the True Cross*
Arezzo, San Francesco

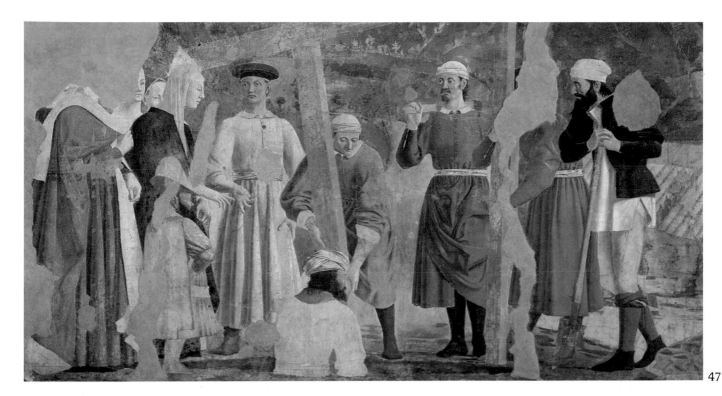

47

48

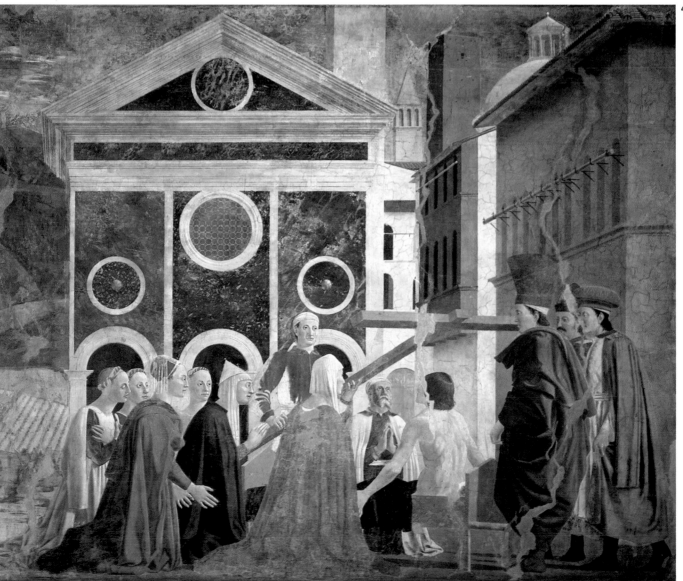

37

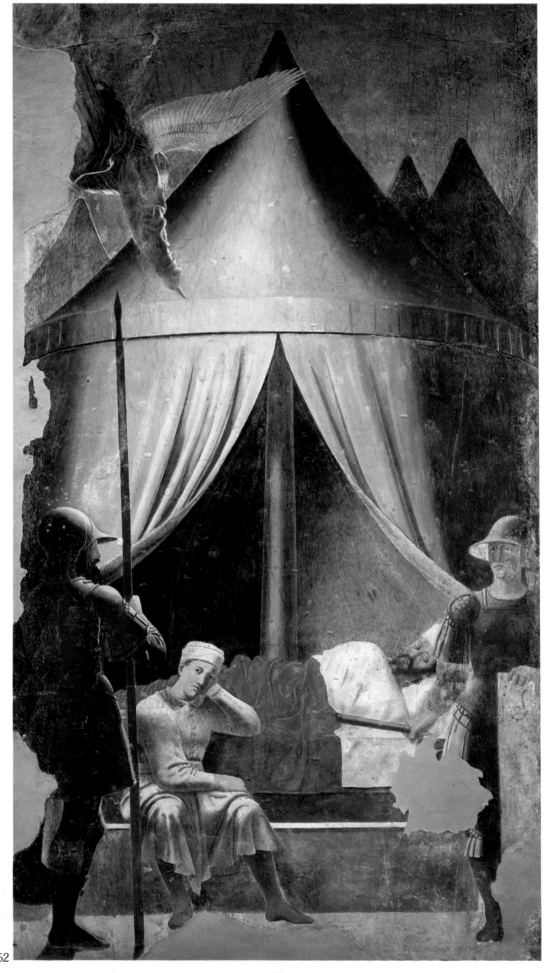

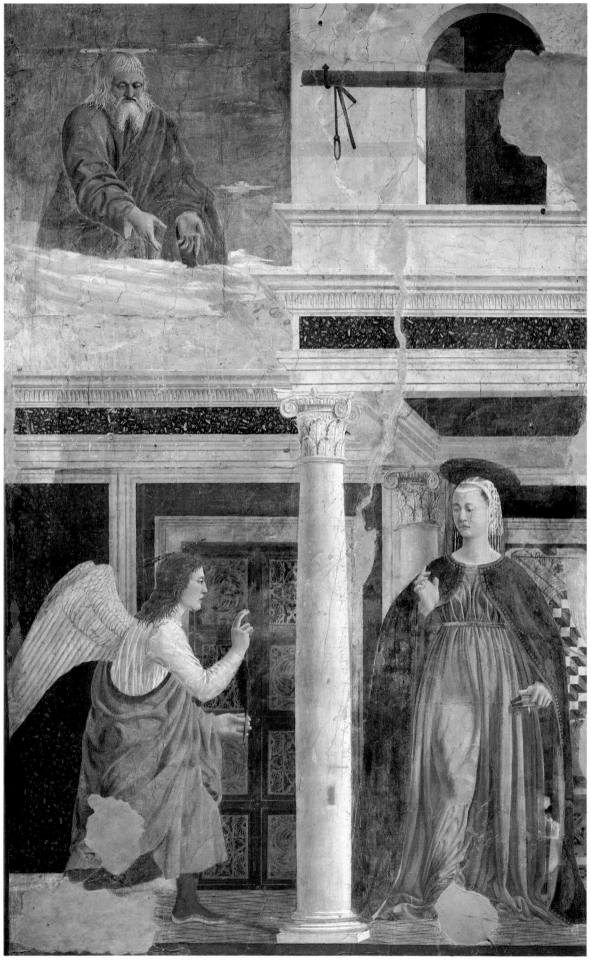

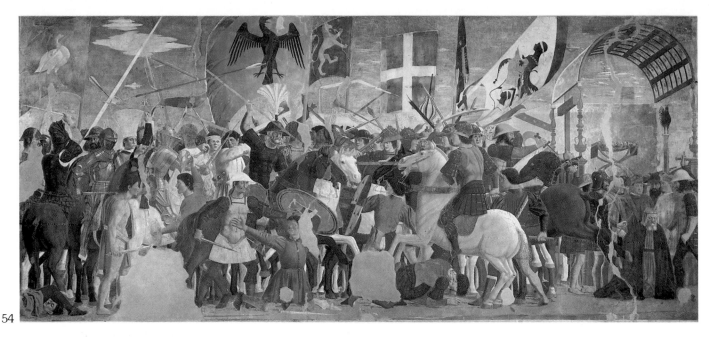

54

vaggio's modern concept of light, the two sentries in the foreground stand out from the darkness, lit only from the sides by the light projected from the angel above.

53 Piero's work on the cycle continued with the *Annunciation*, a subject that has nothing to do with the *Golden Legend* and was added by Piero. Alberti's classical architecture is present once again with the elegant column in the centre, echoed on the right by the statuesque solemnity of the young Mary. And here again the symmetry of the proportions is broken by vanishing point, placed not in the centre but to the right, behind the Virgin. As in all the other later stories, there is great attention to even the smallest detail, brought out by the reflections of the light. From the transparent veil that covers Mary's head, to the pearls that decorate her dress, from the wood intarsia on the door, to the shadows that are projected on the white marble surfaces, there are many new elements that will be further developed in Piero's later works.

54 The last scene Piero painted is almost certainly the *Battle between Heraclius and Chosroes*, on the left wall opposite the *Battle of Ponte Milvio*. Compared to Constantine's battle, depicted as an elegant military parade, this battle is violent and dramatic. Movement is hinted at in this composition which, at least in some parts, suffers slightly from lack of space: the bodies are crammed together in their violent struggle, the drawing that models the mass of limbs is constantly broken

56 57 and interrupted, and the huge horses, rearing in fright, fill much of the scene.

 Yet, despite the allusion, the dynamics of movement have no place in this universe governed *a priori* by thousands of invisible perspective lines. A large part of the actual painting of this last story is undoubtedly the work of an assistant, probably Lorentino d'Arezzo, Piero's most loyal, even though rather mediocre, disci-

ple. The weakness of some parts, painted probably by Lorentino, stands out against the master's powerful art, expressed in a few elements of absolute beauty. Among these, the most famous is certainly the figure of the trumpeter on the left who, in the midst of this dramatic battle, continues to play his instrument. On either side of this figure, the two warriors in their shining armour, with their imposing presence, recall the warriors that Masaccio had painted in Masolino's fresco of the *Crucifixion* in the church of San Clemente in Rome. And this is another element which goes to prove that the last episodes of the *Golden Legend* cycle were painted after Piero's journey to Rome in 1459. 55

54. Battle between Heraclius and Chosroes
329 x 747 cm
Arezzo, San Francesco

55. Battle between Heraclius and Chosroes, detail
Arezzo, San Francesco

56. Battle between Heraclius and Chosroes, detail
Arezzo, San Francesco

57. Battle between Heraclius and Chosroes, detail
Arezzo, San Francesco

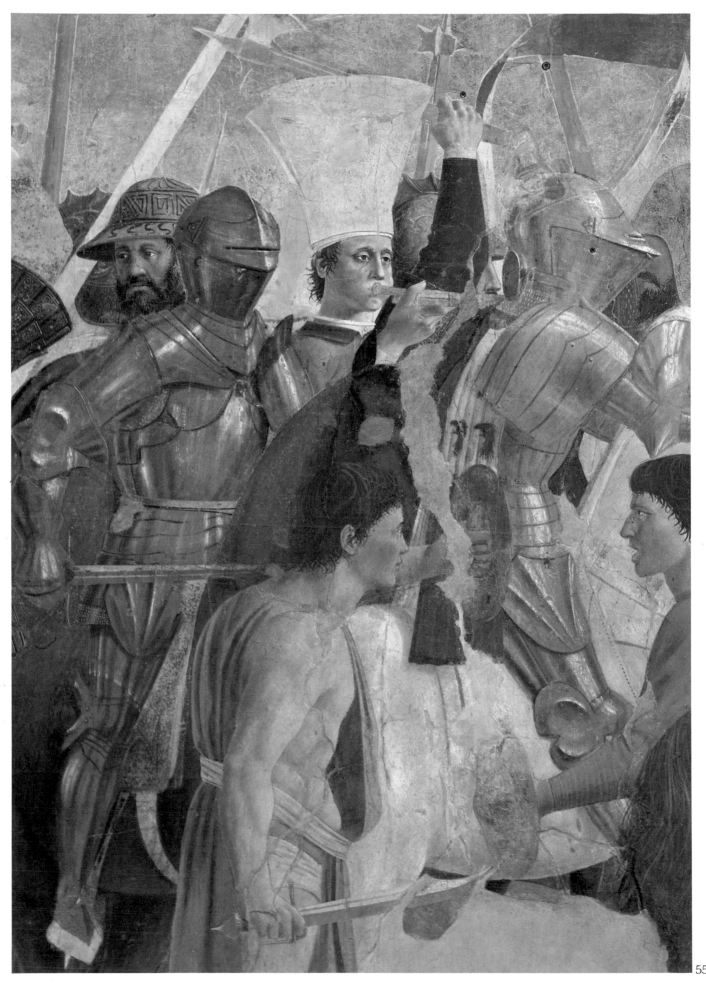

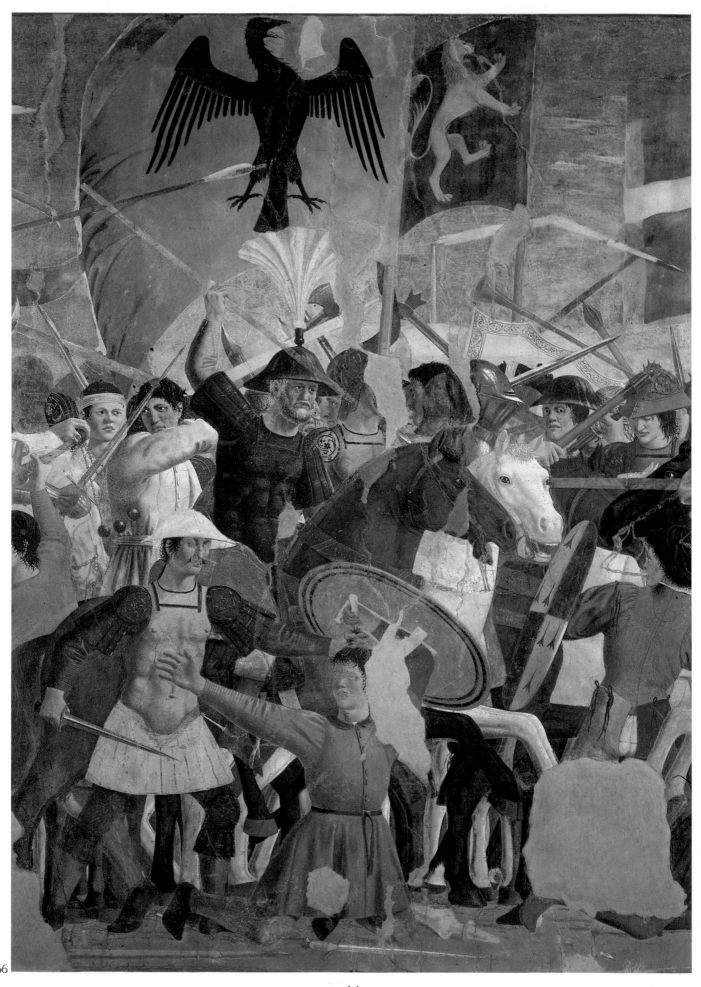

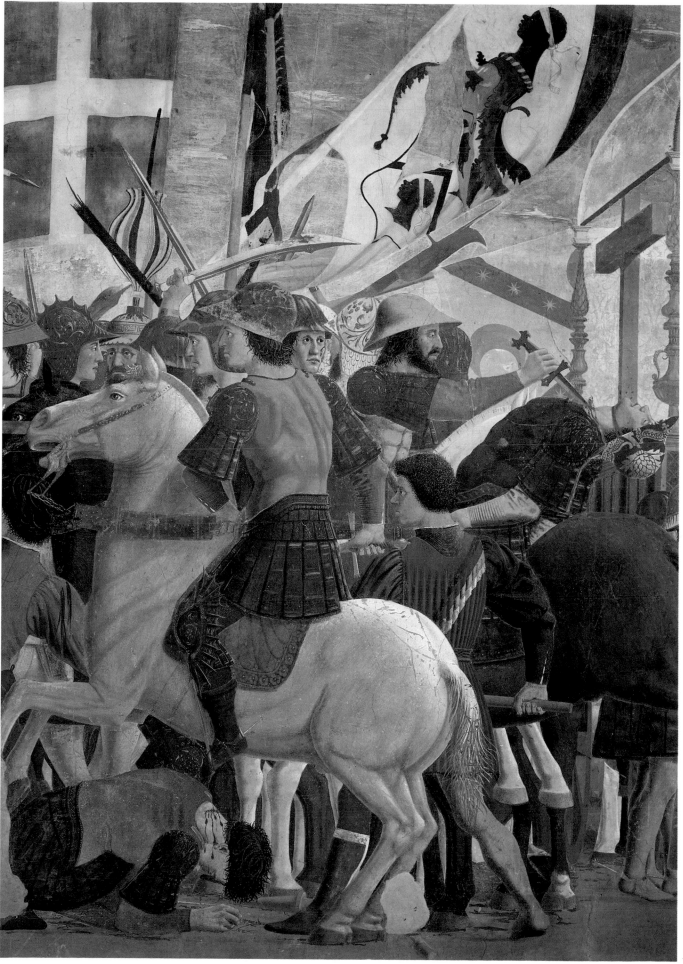

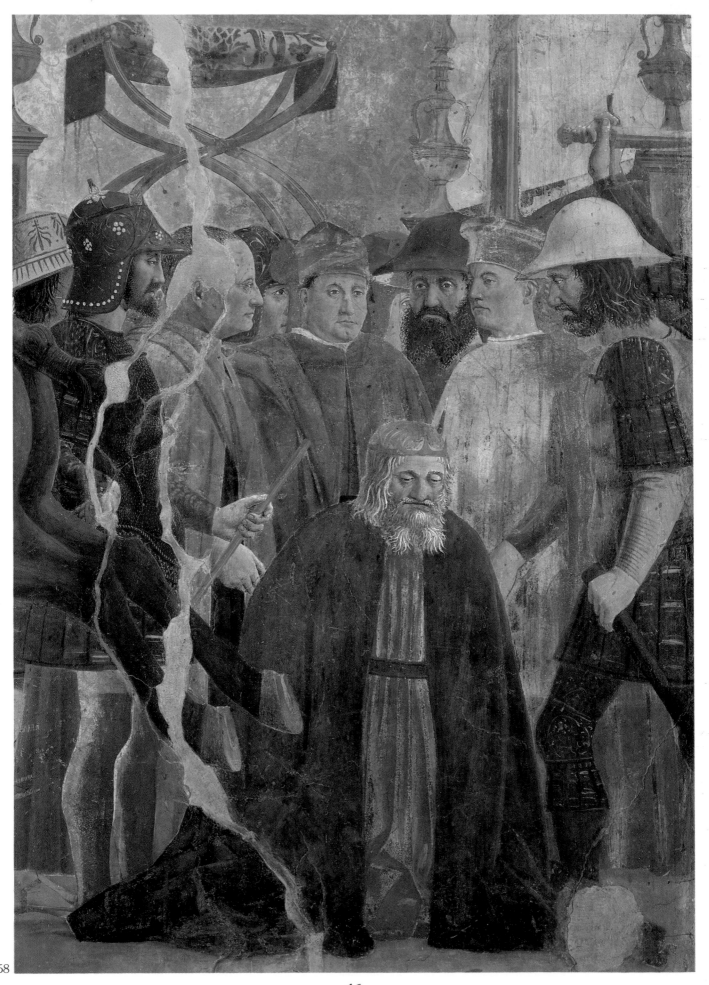

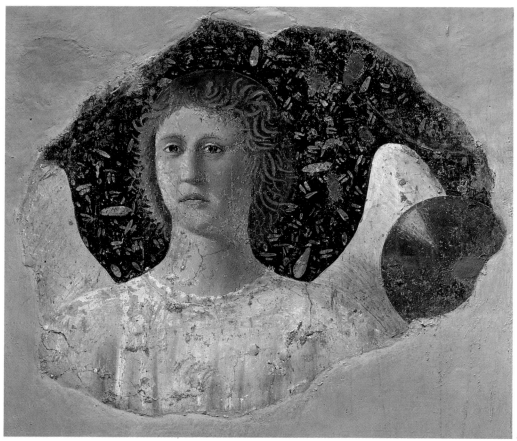

59

Rome, Perugia and Urbino

On the far right, under a canopy decorated with idolatrous symbols, the Persian King Chosroes is about to be decapitated. Around the kneeling sovereign, ready to receive the final blow, are the portraits of three members of the Bacci family. The only one actually painted by Piero, the one on the left shown in profile, is probably the Humanist Giovanni.

Piero was also certainly responsible for painting some now very badly damaged figures that decorate the surrounds of the fresco cycle, such as the bust of *St Peter Martyr*, on the left above the entrance pilaster, and the head of an *Angel*, on the right of the entrance. The solid colour values that are still evident in these fragmentary remains appear to go beyond even the developments in use of colour we have observed in the later stories of the cycle, so that it seems justified to date these works at around the mid-1460s.

The only document we have that gives any indication of when the fresco cycle was finished is a contract, dated December 1466, in which the Arezzo confraternity of the Misericordia commissioned Piero to paint them a standard, qualifying the artist as 'he who painted the Cappella Maggiore in San Francesco in Arezzo.' So we know that by 1466 the frescoes were certainly finished; on stylistic grounds, though, we can say that they were finished several years earlier.

During the period in which he was painting the fresco cycle in Arezzo, Piero della Francesca was also involved with several other commissions in various towns of central Italy. The fresco of the *Madonna del Parto*, painted in the chapel of the cemetery of Monterchi, dates from the same period as the earlier frescoes in Arezzo. The figure of this Madonna, the protector of pregnant women, with her austere expression and natural stance of a woman heavy with child, stands out against the damask canopy, held open at the sides by two angels. The sacred and ritual nature of the image is further emphasized by the fact that the angels are drawn from the same cartoon, repeated in mirror image.

Dating from just a few years later is the only fragment that has survived of Piero's fresco decoration of the church of Sant'Agostino in Borgo San Sepolcro: a bust of *St Julian*. The solidity of his features, and the use of soft colours, relate this proud Christian knight to the young *Prophet* in the Bacci Chapel.

Another one of Piero della Francesca's greatest masterpieces, again painted for his native city, probably just before his journey to Rome in 1458, is the *Resurrection of Christ* in the Palazzo Comunale. This is one of the paintings that best exemplifies Piero's ability

60

61

41

63

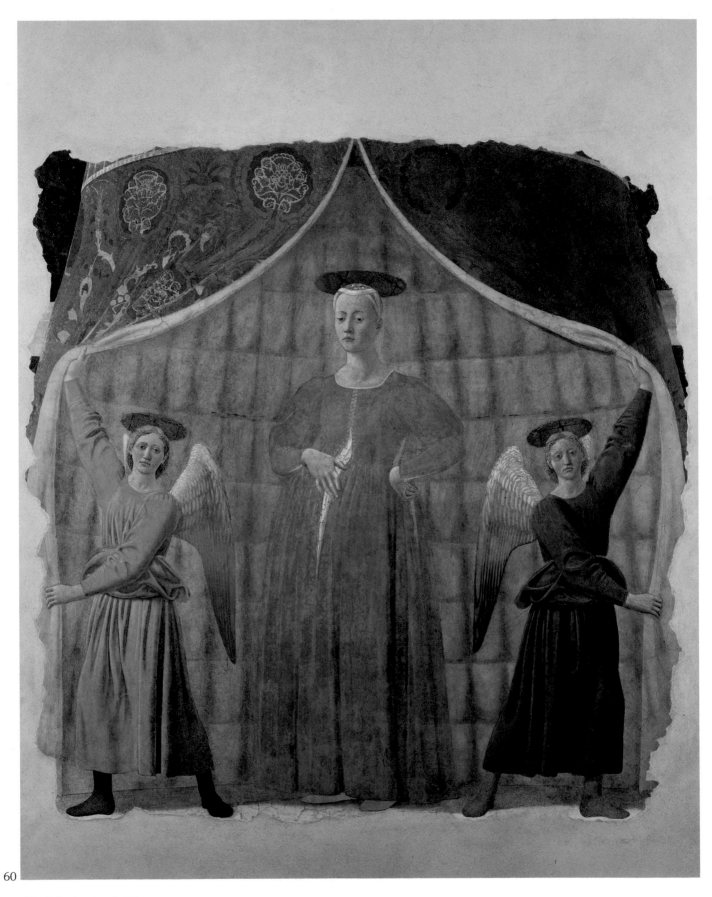

60

60. *Madonna del Parto*
260 x 203 cm
Monterchi, chapel of the cemetery

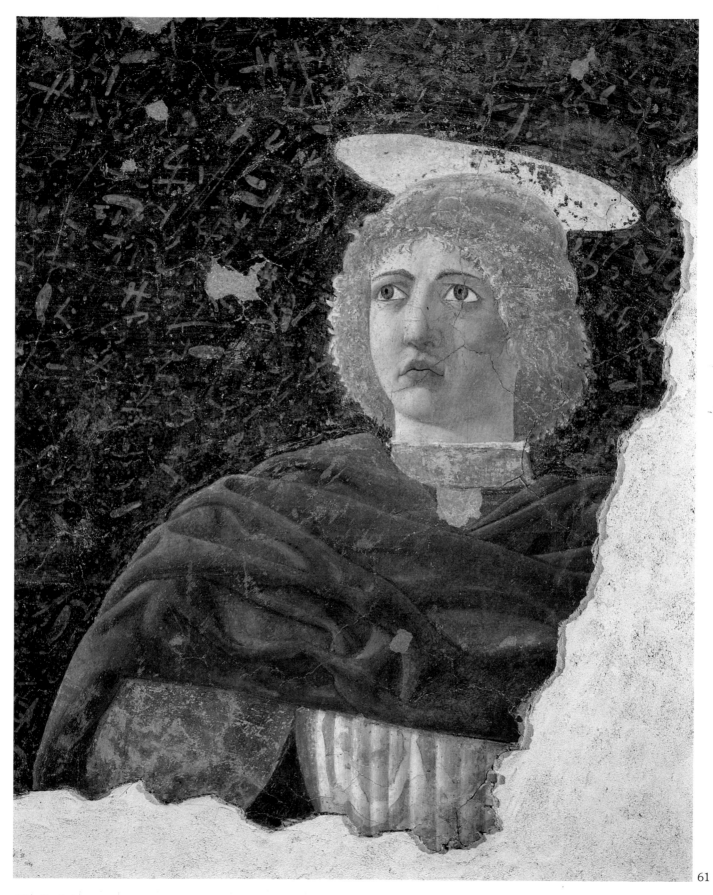

61. *St Julian*
130 x 105 cm
Sansepolcro, Museo Civico

62

62. St Ludovic
123 x 90 cm
Sansepolcro, Museo
Civico

63. Resurrection
225 x 200 cm
Sansepolcro, Museo
Civico

to use archaic iconographical elements, belonging to the repertory of popular sacred images, yet placing them in an entirely new cultural and stylistic context. In this particular case, the splendid transformation of the traditional subject-matter was probably inspired also by the 14th-century polyptych of the *Resurrection* in the Cathedral of Borgo San Sepolcro. Piero takes the construction of his scene from the central panel of this polyptych. Within a framework, formed at the sides by two fake marble columns, Piero's composition is divided into two separate perspective zones. The lower area, where the artist has placed the sleeping guards, has a very low vanishing point. Piero frequently used this technique of lowering the vanishing point.

Alberti, in his theoretical writings, suggests that the vanishing point should be at the same level as the figures' eyes. By placing it on a lower level, Piero foreshortens his figures, thus making them more imposing in their monumental solidity. Above the figures of the sleeping sentries, Piero has placed the watchful Christ, no longer seen from below, but perfectly frontally. The resurrected Christ, portrayed with solid peasant features, is nonetheless a perfect representative of Piero's human ideal: concrete, restrained and hieratic as well. The splendid landscape also belongs to the repertory of popular sacred images: Piero has symbolically depicted it as half still immersed in the barenness of winter, and half already brought back to life—

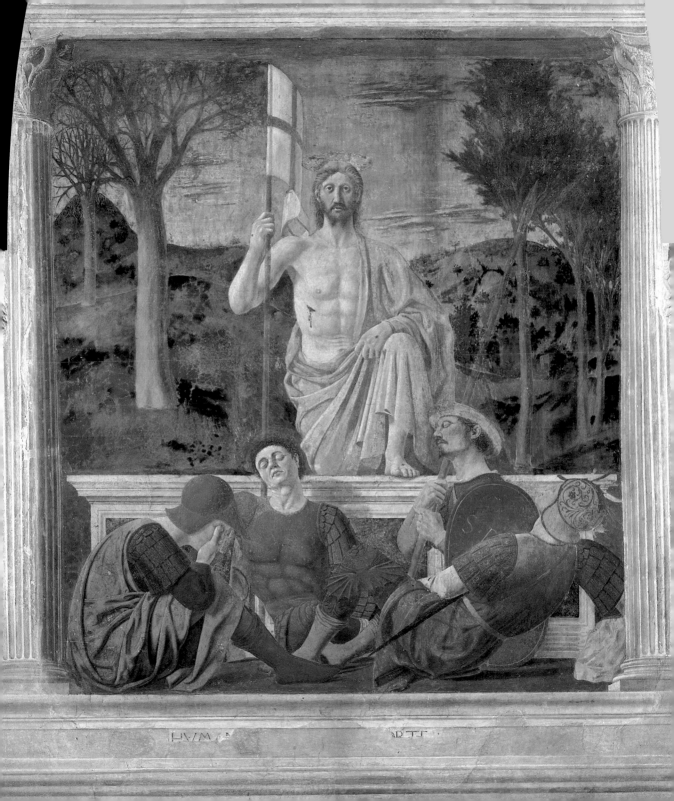

64

64. *St Luke the Evangelist*
Rome, Santa Maria Maggiore

65. *Polyptych of the Misericordia detail of the Madonna of Mercy*
134 x 91 cm
Sansepolcro, Museo Civico

resurrected—by springtime.

Unfortunately nothing remains of the work Piero della Francesca did in Rome, where he worked in the Vatican for Pius II between 1458 and 1459. His frescoes, which were probably as grandiose as those of the Arezzo cycle, were soon destroyed and the importance of this Roman period is confirmed only by the profound influence his perspective vision left in the works of artists such as Antoniazzo Romano, Lorenzo da Viterbo and Melozzo da Forlì. The few fragments of a fresco showing *St Luke the Evangelist* in the chapel of Cardinal d'Estouteville in the church of Santa Maria Maggiore are the work of one of these Roman artists, who painted the figure following a cartoon designed by Piero himself. It seems likely that Piero visited Rome several times after he left Florence. In fact it is very probable, as Vasari suggests, that Piero first went to Rome, perhaps even accompanied by Alberti, as early as the 1440s, during the papacy of Eugene IV or Nicholas V. Here he would have contributed to setting up in the Vatican, where Fra Angelico and Jean Fouquet were already active, an alternative to Florentine artistic trends. But unfortunately all evidence of these important cultural developments is lost.

In 1462, Piero's brother Marco collected the final payment due to the artist from the confraternity of the Misericordia for the polyptych begun back in 1445. The last part of the polyptych, painted by Piero in the early 1460s, is the central panel, showing the *Madonna della Misericordia* (Madonna of Mercy).

The difficulty of dealing with a solid gold background, requested by the patrons, is solved here by Piero by placing the kneeling members of the confraternity in the realistic space created by the Madonna's mantle, held open around the figures like the apse of a church. The perfectly central positioning of the Virgin and the fact that she is seen frontally are reminiscent of the same atmosphere of hieratic solemnity in the *Resurrection*. But there are several new elements in the kneeling figures, and in their garments, that suggest a slightly later date: there is, for example, a greater attention to the light reflections on the characters' hair, and there is a more refined technical ability in rendering the various textures and patterns of the fabric.

More or less at the same time as he was working on the final scenes of the San Francesco cycle, Piero was given another important commission in Arezzo: the fresco of *Mary Magdalen* in the Cathedral. This monumental figure is created entirely by large patches of bright colours, rather like an early 16th-century Venetian painting. Yet even with this new use of colour Piero still concentrates on the attention to detail typical of his mature works: the shining light reflections on the small bottle, the hair that is depicted strand by strand on the saint's solid shoulders.

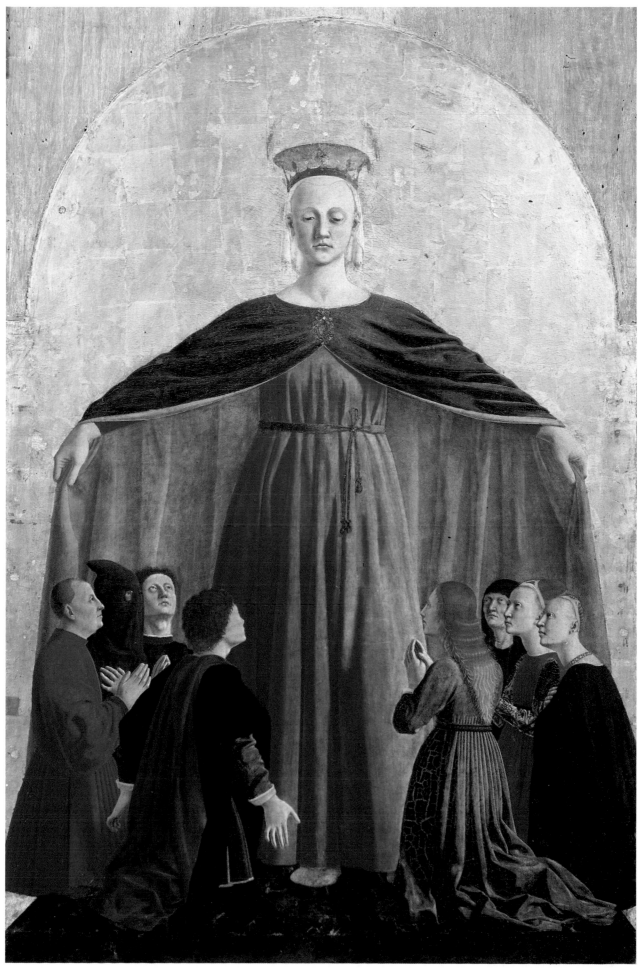

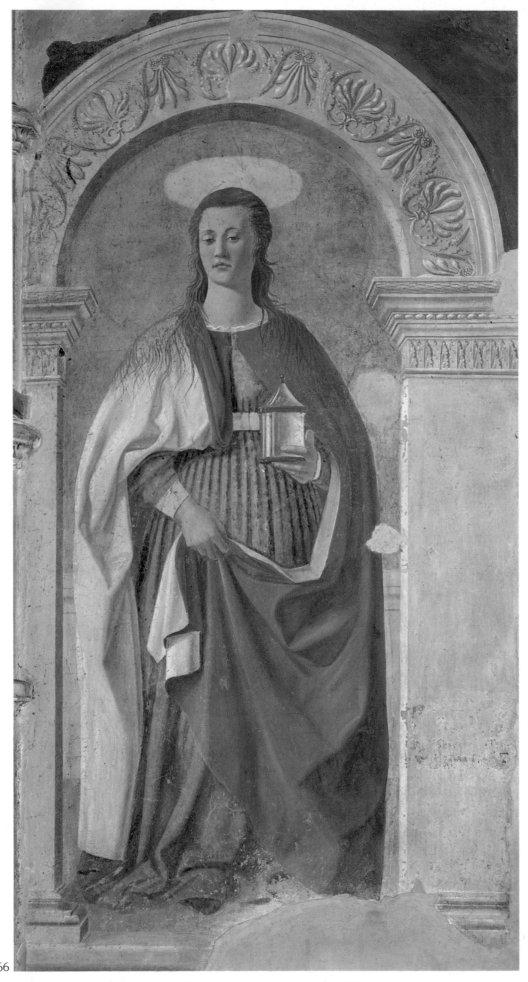

66. Mary Magdalen
190 x 105 cm
Arezzo, Cathedral

67. Polyptych of St
Anthony
338 x 230 cm
Perugia, Galleria
Nazionale

66

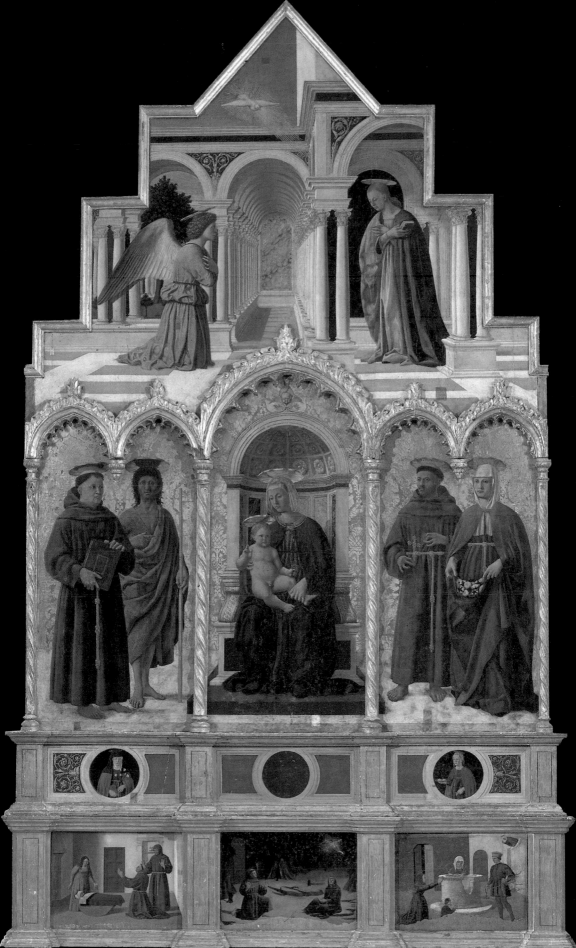

68. Polyptych of St Anthony
detail of the Madonna and
Child
141 x 65 cm
Perugia, Galleria Nazionale

69. Polyptych of St Anthony
detail of St Anthony and St
John the Baptist
124 x 62 cm
Perugia, Galleria Nazionale

70. Polyptych of St Anthony
detail of St Francis and
St Elizabeth
124 x 64 cm
Perugia, Galleria Nazionale

68

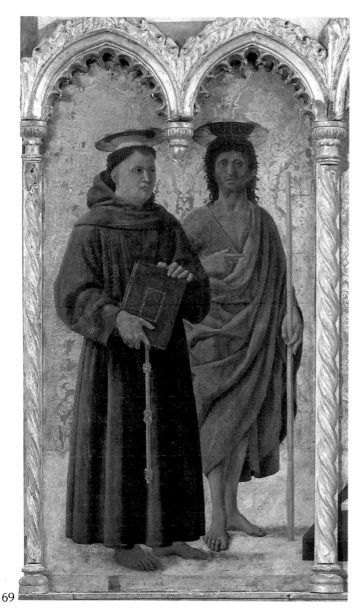

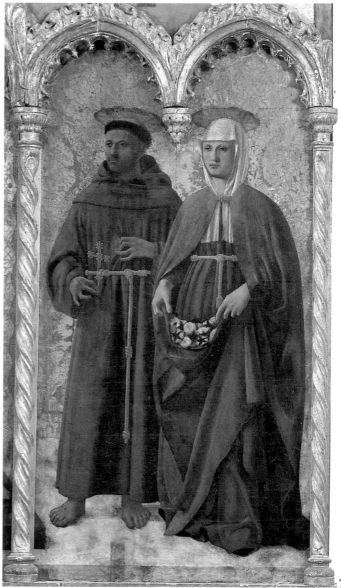

Among the many works that, according to Vasari, Piero painted in Perugia, the historian describes with great admiration the polyptych commissioned by the nuns of the convent of Sant'Antonio da Padova. This complex painting, today in the Pinacoteca Nazionale in Perugia, was begun shortly after Piero's return from Rome, but was not completed for several years. The central part of the composition, the *Madonna and Child with Saints Anthony, John the Baptist, Francis and Elizabeth*, reveals in its unusual damask-like background the artist's acquaintance with a trend of contemporary Spanish painting, which Piero would have had the opportunity to see in Rome. We can therefore date the panel at around 1460. The polyptych is also made up of three predella panels showing *St Anthony of Padua resurrecting a child*, the *Stigmatization of St Francis* and *St Elizabeth saving a boy who had fallen down a well*, as well as two roundels placed between the main panel and the predella. The quality of this predella is extraordinary: Piero's characteristic spatial

and light values are achieved here, on a small scale, by emphasizing the white walls of the interiors, the splashes of light and the deep shadows of the night scene in the open countryside. These scenes, where the bodies and even the shadows are fully three-dimensional, were to set an example for predella panels which was widely followed by Italian artists of the second half of the 15th-century, from the young Perugino to Bartolomeo della Gatta and, via Antonello da Messina, to the Neapolitan 'Master of Saints Severino and Sossio.' A few years later, Piero della Francesca completed the Perugia polyptych: above the ornate and still basically Gothic frame, he painted his extraordinary *Annunciation*.

The lack of compositional unity with the central part of the polyptych has led some scholars to suggest that Piero simply added this *Annunciation* to the altarpiece, much later.

But, on the contrary, the whole polyptych has a structural unity; Piero simply cut out the top part, orig-

71

72

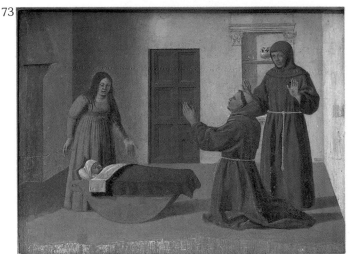

73

74

71-75. Polyptych of St
Anthony
details of the predella:
St Clare (71)
St Agatha (72)
St Anthony of Padua
resurrects a child (73)
36 x 49 cm
St Elizabeth saves
a boy who has fallen
down a well (74)
36 x 49 cm
The Stigmatization of
St Francis (75)
36 x 51 cm

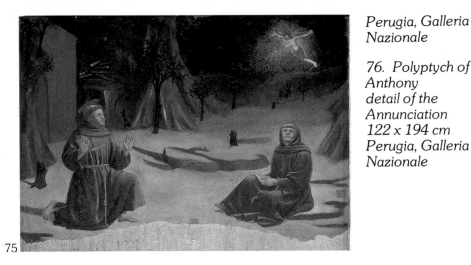

75

Perugia, Galleria
Nazionale

76. Polyptych of St
Anthony
detail of the
Annunciation
122 x 194 cm
Perugia, Galleria
Nazionale

inally intended to be rectangular, and transformed it into a sort of cusped crowning. Once again Piero has succeeded in overcoming the limitations imposed by patrons with old-fashioned artistic taste, giving us one of the most perfect examples of his use of perspective. Thanks also to his use of oil paints, Piero della Francesca achieves the extraordinarily detailed depiction of the series of capitals, running towards the vanishing point. Each architrave, and each column as well, projects a thin strip of shadow into the splendid cloister arcade, which appears to go beyond any inspiration derived from Alberti's architecture. The subtle analysis of the decorations painted on the walls reaches an unprecedented level; yet everything is contained in a single and organic space. Distances, so perfectly calculated, are neither forced nor artificial: they

are conveyed by the realistic light and atmosphere, as had been the case almost twenty years earlier in the Urbino *Flagellation*.

In 1454 Piero della Francesca agreed to paint a polyptych for the Augustinians of Borgo San Sepolcro; the painting was to be finished within eight years and was intended for their monastery. As usual, the work was not completed until much later; the final payment for the painting was not made until 1469. Due to the historical events concerning the monastery in Borgo San Sepolcro, the polyptych was later replaced and dismembered. It was only in this century that scholars succeeded in reconstructing this work, Piero's last surviving polyptych. None of the panels that survive appear to have been painted in the 1450s, in other words at the time the contract was signed. The

2

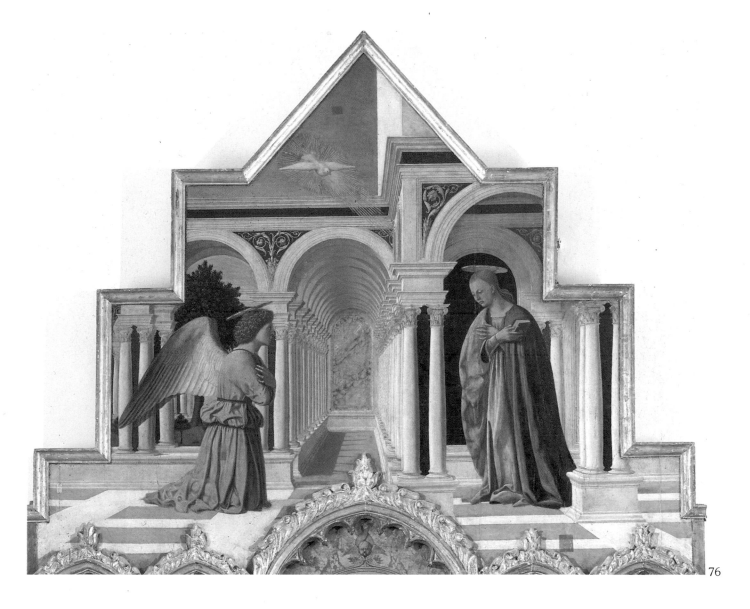

76

oldest parts date from the early 1460s, and are contemporaneous with the last frescoes in Arezzo and with the central panel of the Perugia polyptych.

77
78
The panels that originally formed the predella—*St Monica*, an *Augustinian Saint* and the *Crucifixion*, all in the Frick Collection in New York—are clearly reminiscent of Piero's synthetic style adopted for a small scale, which characterized the predella and the outer decorations of the polyptych of Perugia. *St John the Evangelist*, also in the Frick Collection in New York, and *St Nicholas of Tolentino*, in the Poldi-Pezzoli Museum in Milan, date from the mid-1460s, the busiest period in Piero's career.

79
Against a background, which is neither made of gold, like the Misericordia polyptych, nor of damask, like the Perugia polyptych, but which is finally a realistically constructed space with a marble balustrade, stands the figure of *St John*, whose features anticipate those of the saints of the Brera altarpiece. Compared to the full and solid bodies of the Misericordia altarpiece, this figure of the Evangelist expresses more movement; he is dynamic yet elegant. His lined face,

surrounded by white hair, his bony hand weighted down by the heavy book, even the ornate borders of the garment that unexpectedly shows through under the wide cloak, are elements that stand out and appear to force their way through Piero's earlier sense of measure. *St Nicholas of Tolentino* is a more original 80 figure: the austere and calm features of his round face almost create the effect of a portrait. But all elements of realism are, as usual, absorbed by the aristocratic sense of regularity; each detail of this painting is rendered with a unity of lighting that anticipates certain trends in 17th-century painting. The two panels with *St Augustine*, now in the Lisbon museum, and *Archangel Michael*, in the National Gallery of London, belong to Piero's late period (1469-70). *St Augustine*, por- 81 trayed with a mitre and a splendid bishop's cope, is one of the high points of Piero's painting, for here he achieves perfect harmony between the imposing solidity of his three-dimensional forms and his miniaturistic attention to detail, observed down to the subtlest aspects of reflected light.

Since the art of Gentile da Fabriano, no Italian

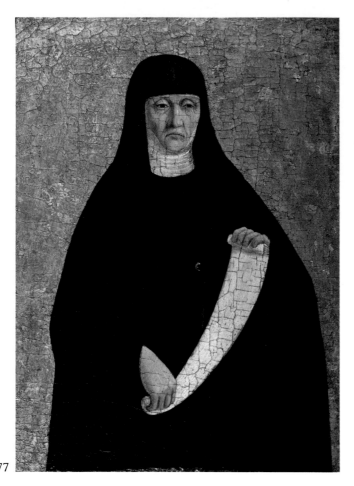

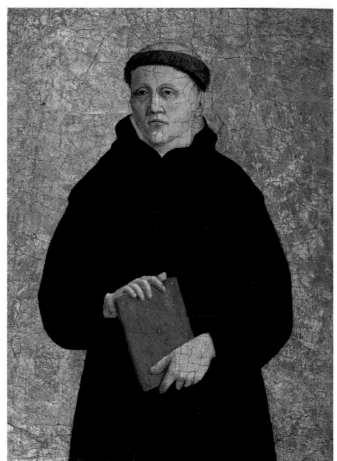

painter had succeeded, at such a high qualitative level, in giving such a detailed reproduction of a saint's vestments. Having fully mastered the secrets of Netherlandish art, Piero della Francesca paints every single scene depicted on this precious cope as though he were painting a small predella panel, using, for the soft decorations of the fabric, a 'dot' technique worthy of a miniature by Fouquet. And yet it is still the monumental values that prevail in the figure of this severe saint. *Archangel Michael* is portrayed as an ancient warrior, his athletic limbs made more elegant by his precious armour, by the graceful tunic and by his beautiful boots decorated with tiny pearls. There is nothing violent nor dramatic in the killing of the dragon, who is shown as a snake, its decapitated body lying on the ground. The usual absence of movement, that characterizes all Piero's compositions, is here enhanced by the feeling of graceful elegance conveyed by the saint's gesture, for he holds the severed snake's head with the same delicacy with which one would touch a precious gem.

Among the parts of the polyptych that have unfortunately not survived, there is also the central panel, which almost certainly showed the *Madonna and Child*. The panel with *St Apollonia*, now in the National Gallery in Washington, although it is exactly the same size as the two saints in the Frick Collection, was

probably not part of this polyptych, but of another one also painted for Borgo San Sepolcro. In fact, the source of light in the *St Apollonia* panel is on the opposite side compared to the Frick paintings, and Piero della Francesca was always extremely careful not to alter the lighting or the spatial construction within a single composition.

Towards the middle of the decade, the artist also painted for Borgo San Sepolcro the fresco of *Hercules*, later removed and now in the Gardner Museum in Boston. This Hercules was probably originally part of a series of mythological characters or famous men. Looking at this nude, which more than any other of Piero's subjects could have lent itself to the imitation of examples from classical art, we can see how the artist always refused borrowings from antiquity, unlike other artists who followed the 'archeological' trend of the time. As in the case of many of his Florentine contemporaries, classical art was for Piero a stimulus in the literary sense, which fuelled his imagination and suggested images to him, but was never a source of direct inspiration. This tall, strong figure, with his modern hairstyle, portrayed in a 15th-century room, is totally unrelated to the sculptures from classical antiquity that Piero had become acquainted with in particular during his stay in Rome.

Towards 1465, the artist resumed his contacts with

82

83

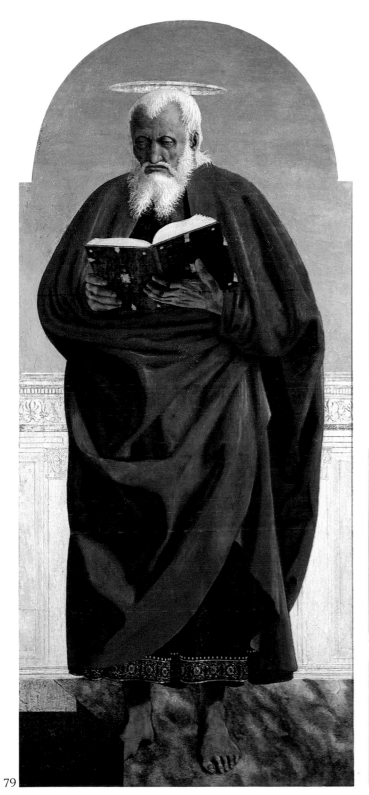

79

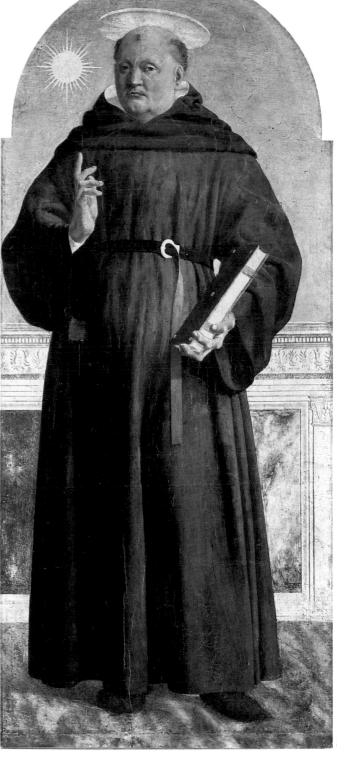

80

77. *St Monica*
39 x 28 cm
New York, Frick Collection

78. *Augustinian Saint*
39 x 28 cm
New York, Frick Collection

79. *St John the Evangelist*
131.5 x 57.5 cm
New York, Frick Collection

80. *St Nicholas of Tolentino*
133 x 60 cm
Milan, Museo Poldi Pezzoli
One notes the difference in colour between this panel
and the one to the left, which has recently been
restored.

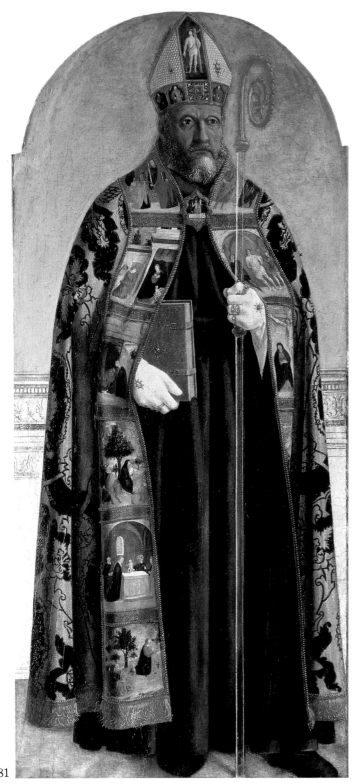

81

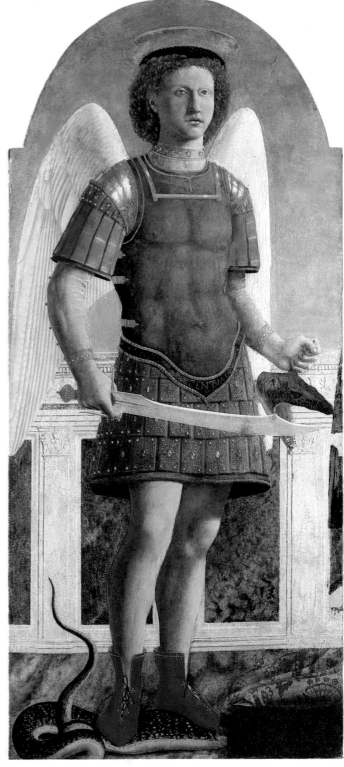

82

the Montefeltro family in Urbino, who became his most generous patrons. The famous diptych with the
84 portraits of *Battista Sforza* and *Federico da Montefel-*
85 *tro*, today in the Uffizi in Florence, can be dated at the very beginning of this period. In these two relatively small panels, Piero attempts a very difficult compositional construction, that had never been attempted before. Behind the profile portrait of the two rulers, which is iconographically related to the heraldic tradi-

tion of medallion portraits, the artist adds an extraordinary landscape that extends so far that its boundaries are lost in the misty distance. Yet the relationship between the landscape and the portraits in the foreground is very close, also in meaning: for the portraits, with the imposing hieratic profiles, dominate the painting just as the power of the rulers portrayed dominates over the expanse of their territories. The daringness of the composition lies in this sudden switch between

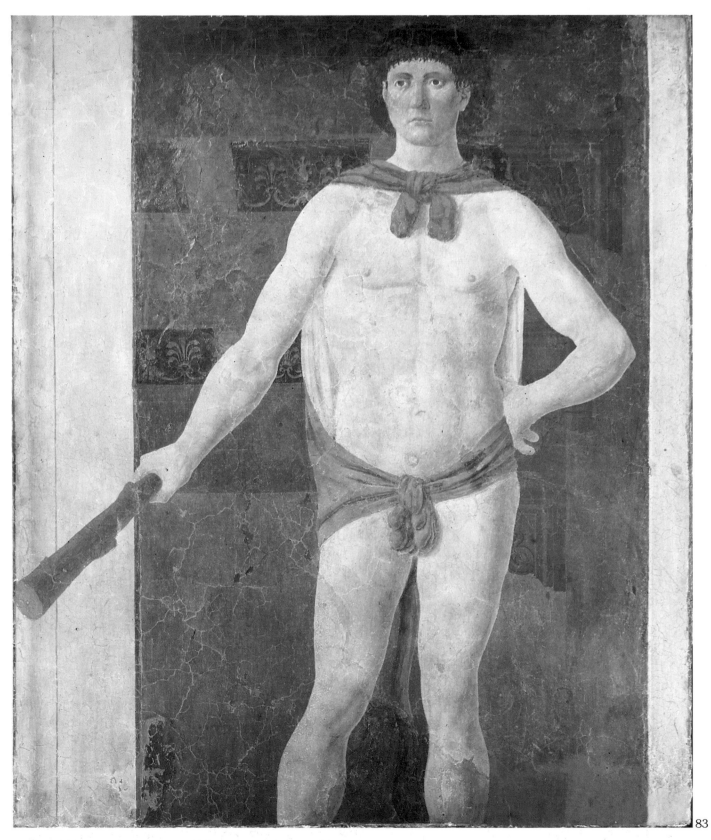

83

81. *St Augustine*
133 x 60 cm
Lisbon, Museu de Arte Antigua

82. *Archangel Michael*
133 x 59 cm
London, National Gallery

83. *Hercules*
151 x 126 cm
Boston, Isabella Stewart Gardner Museum

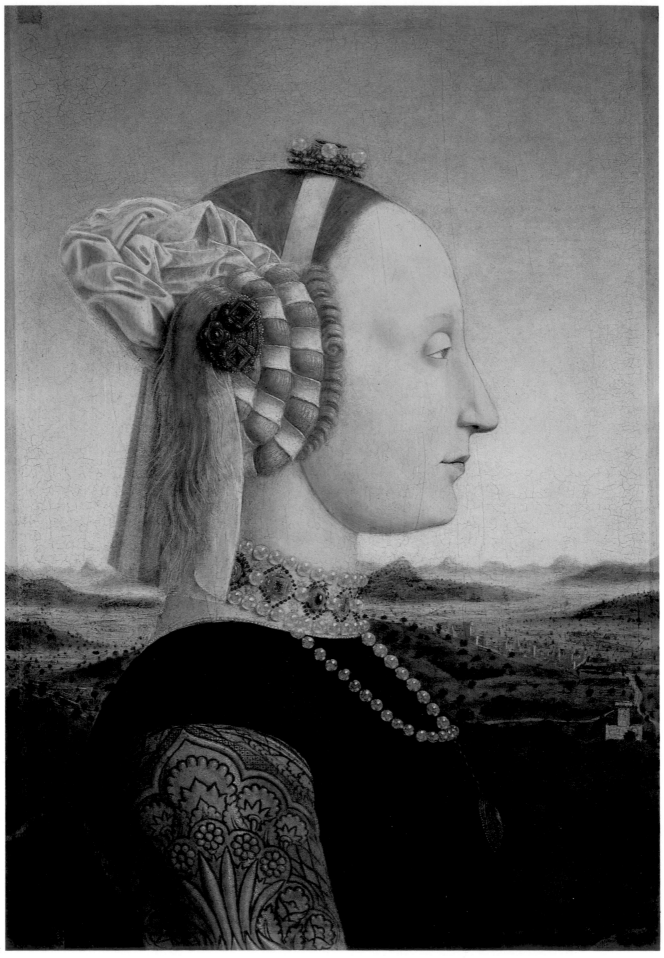

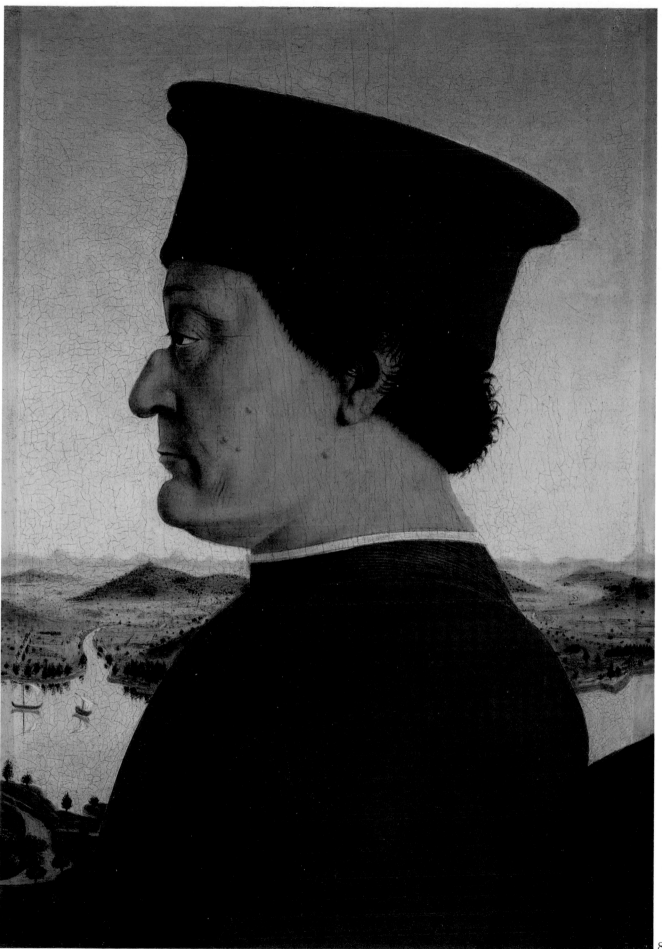

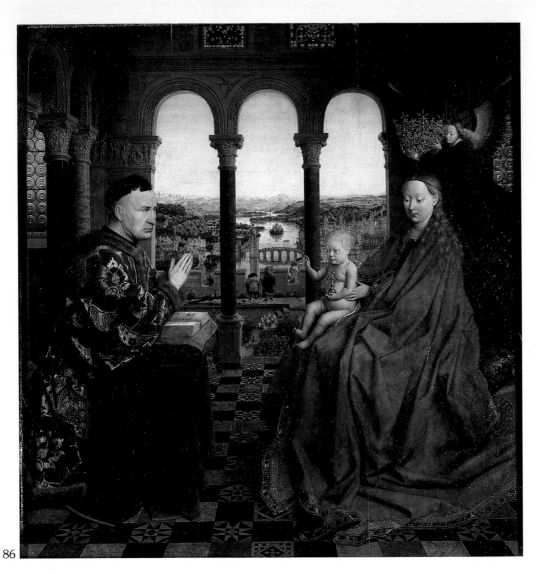

86

86 such distant perspective planes. Even Jan Van Eyck, for example, in his large painting of the *Madonna of Chancellor Rolin*, had felt the need to place an architectural balustrade between his figures in the foregound and his landscape in the background, to bridge the gap. In the portraits of the Duke and Duchess, Piero reveals once again his great ability to simplify shapes and to convey three-dimensionality; and Federico's aquiline profile almost becomes an image of abstract and geometric purity.

Piero's ability in rendering volumes is accompanied by his attention to detail, by now a constant in his art. Through his use of light, he gives us a miniaturistic description of Battista Sforza's jewels, of the wrinkles, moles and blemishes on Federico's olive-coloured skin. Apart from Antonello's slightly later works, in no other 15th-century European painting is such a remarkable synthesis achieved between the accurate depiction according to the rules of linear perspective, as elaborated by Italian art, and 'miniaturistic' painting obtained thanks to the technique of oil paints, developed to such an extraordinary degree by Netherlandish artists. The greatness of Piero's art, rather than in his radical

break away from traditional patterns, lies in this unique ability to harmonize elements from such different cultures, and transform them into a universal language.

On the reverse of the two portraits Piero has depicted the *Allegorical Triumphs* of the rulers of Urbino. Here the landscape becomes more dominant, and almost acquires independent life. Before these two panels were placed in their modern frame, the two views of Federico's territorial domains formed a single composition. The expanse of peaceful, luminous water, like a mirror at the feet of Montefeltro's gently sloping hills, must have made this composition seem even more innovative compared to similar depictions of landscape by Florentine or Northern artists.

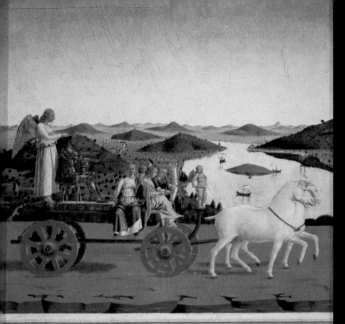

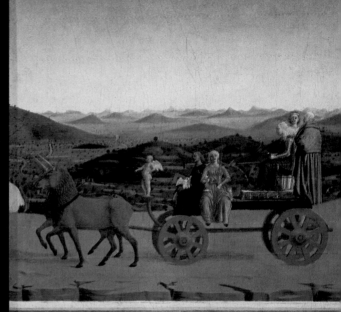

CLARVS INSIGNI VEHITVR TRIVMPHO ·
QVEM PAREM SVMMIS DVCIBVS PERHENNIS ·
FAMA VIRTVTVM CELEBRAT DECENTER ·
SCEPTRA TENENTEM ·

QVE MODVM REBVS TENVIT SECVNDIS ·
CONIVGIS MAGNI DECORATA RERVM ·
LAVDE GESTARVM VOLITAT PER ORA ·
CVNCTA VIRORVM ·

Piero's Late Works and the Development of Linear Perspective in Italian Painting

Piero della Francesca's connection with the artistic environment of Urbino is documented by several records proving the artist's presence in that city on several occasions during the last twenty years of his life. In 1469 he was in contact with the Urbino painter Giovanni Santi regarding the execution of a painting for the confraternity of Corpus Domini. The predella of the painting had already been carried out by Paolo Uccello; for some reason, in the end Piero did not paint the altarpiece, and the commission was passed on to the Netherlandish artist Justus van Ghent. This interchange between Italian and Netherlandish artists, who often replaced each other in commissions even in such a small centre as Urbino, is a further demonstration of what an artistic crossroads this town had become; it was the meeting ground of the most varied cultural trends, and was rapidly becoming one of the leading and most progressive Italian artistic centres of the time. Evidence of the highly important role played by Piero in Urbino in the 1470s is offered by the unmistakeable influence his art had on all the painters working in the city at the time, including those of Netherlandish background, such as Pedro Berruguete, who within a few years became entirely 'converted' to the fundamental scientific rules of perspective art. And even in the field of literature Piero's important role is recognized by the theoretical writers working in Urbino in the second half of the 15th century. There must have been theoretical discussions concerning the problems of perspective and of proportions, much as there had been in Florence in the early 15th century. In his *Cronaca rimata*, Giovanni Santi praises Piero, calling him one of the major artists of the century, and Luca Pacioli, a pupil of Piero's, wrote a theoretical treatise that was based entirely on the master's thoughts and ideas. All this is evidence of the fact the Piero della Francesca was admired not only for his paintings, but also for his theoretic ability.

89 Two small panels, the *Madonna and Child with Angels* in the Clark Institute in Williamstown and the *Madonna of Senigallia* in the National Gallery in Urbino, date from the early 1470s. The former is a masterpiece of study in proportions and in the subtle relationships between figures and architecture, as some of the frescoes in the church of San Francesco in Arezzo had been. This small panel is reminiscent of some of the Arezzo compositions also in the way it creates a sense of chance in the placing of the figures in semi-circles. It is from paintings like this one that Piero's faithful pupil, Luca Signorelli, was influenced at first, at least until 1475, when the novelties arriving from the Florentine artistic world entirely changed his original style. In fact, the young Luca Signorelli is undoubtedly the closest follower of Piero, as can readily be seen from his two versions of the *Madonna and Child with Angels*, one in Boston and one in Oxford, and from the *Madonna and Child* in the Cini Collection; these works are comparable, but at a far higher level of quality, to the imitations of Piero's work carried out by Lorentino d'Arezzo.

90 The *Madonna of Senigallia*, originally in the church of Santa Maria delle Grazie in Urbino, is quite different from Piero della Francesca's previous production, particularly in the type-casting of the figures. The faces still have an expression of aloofness and of superior rational wisdom, but they also convey a sense of precious, almost exotic, beauty. This is one of the paintings in which the artist most clearly reveals his interest in light values, both in terms of reflections and of magical transparencies. From Mary's veil, slightly puckered on her forehead with subtle light variations, to the coral necklace around the Child's neck, to the angels' shining pearls—these are all effects which, together with the light streaming in from the window, and forming a perfectly geometrical shape on the end wall, will appear again and again in Dutch painting of the 17th century.

The blonde hair of the angel on the left, because of the reflection of the light coming in from behind, acquires an almost magical golden glow, as though it were a natural halo.

44 As we mentioned earlier, in the Arezzo fresco of the *Burial of the Wood of the Cross*, Piero created a similar effect of a natural halo with the veins of the wood behind the head of one of the characters. With the use of these original inventions, the artist seems almost to be constructing his sacred image by making conventional mystical portents fit into the natural world, an idea that was first used by Masaccio and, before him, by Giotto. Giotto, in fact, had been the first artist to

89. Madonna and Child with Angels
106x78 cm
Williamstown, Clark Institute

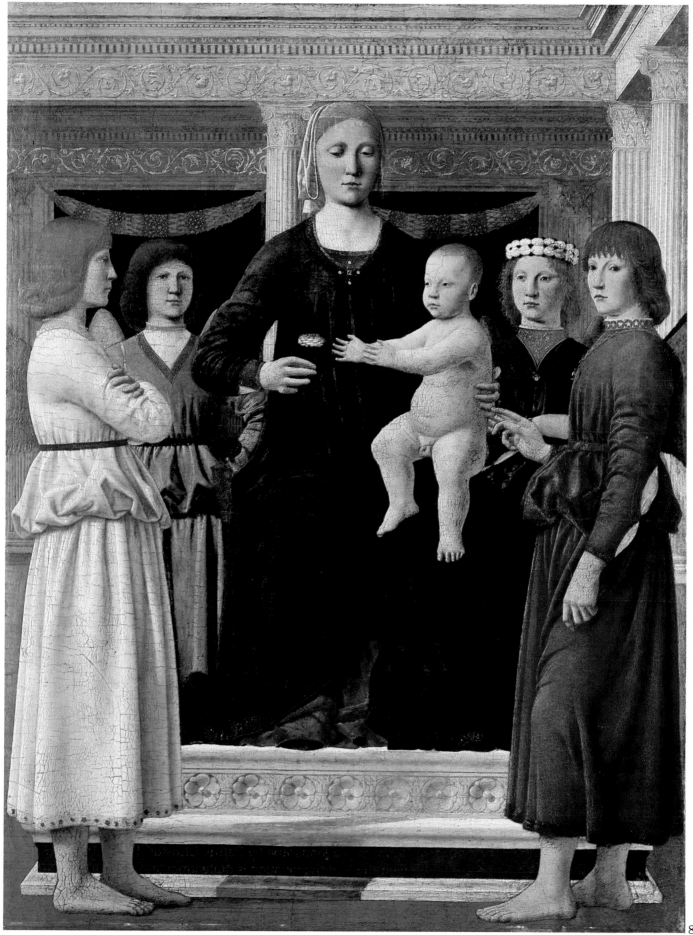

paint saints' haloes according to the strict rules of perspective, showing them foreshortened as any real object would have been. Masaccio, in his polyptych for the Carmelites of Pisa, had painted the haloes as solid objects, with a definite spatial depth, with the result that they are almost like plates or bowls hovering behind his saints' heads. Piero della Francesca, as he gradually became more interested in the depiction of natural reality—although he never entirely abandoned the elements of popular tradition and of ritualistic sacred images, as we have seen in his paintings for Borgo San Sepolcro—tended to eliminate wherever possible the depiction of such an abstract object, so far removed from his visual knowledge. All elements of naive medieval tradition are banished from the solid and mature awareness of Piero's sacred figures; they have no need to resort to outward symbols to demonstrate their divine nature.

Shortly after the *Madonna of Senigallia*, Piero set to work on the most grandiose of his paintings dating from this period. This was the huge altarpiece showing the *Madonna and Child with Saints*, today in the Pinacoteca di Brera in Milan. Probably painted for the church of the Osservanti di San Donato in Urbino, this panel was transferred, after the death of Federico in 1482, to the church of San Bernardino, the modern mausoleum built for the deceased Duke. Federico da Montefeltro, shown kneeling at the foot of the Madonna's throne, is portrayed in his warrior's armour, but without the insignia awarded to him by Pope Sixtus IV in 1475.

The absence of these emblems, which Piero would certainly have included in an official portrait like this one, leads us to date the splendid Brera altarpiece, previously believed to be Piero's last work, at around 1472-74. The complex and majestic architectural background, against which the 'sacra conversazione' takes place, is clearly derived from designs very similar to the ones followed by Alberti in his construction of the church of Sant'Andrea in Mantua. Yet, at the same time, the architecture anticipates certain 'classical' elements which will be used by the young Bramante—another extraordinary artist from Urbino. In this painting, too, the artist's mastery of proportions is remarkable; it is almost symbolized by the large ostrich egg hanging from the shell in the apse. The shape of this symbolic element is echoed by the near perfect oval of the Madonna's head, placed in the absolute centre of the composition. In this painting Piero places his vanishing point at an unusually high level, more or less at the same height as the figures' hands, with the result that his sacred characters, placed in a semicircle, appear less monumental. Piero's extraordinary invention of an architectural apse echoed below by another apse, consisting in the figures of the saints gathered around the Madonna, was taken up time and

again by artists working at the end of the 15th century and at the beginning of the 16th, particularly in Venice, starting with the almost contemporary paintings of Antonello da Messina and Giovanni Bellini. This organized composition, typical of Piero's work, contained within a unity of space and lighting, seems however to have a new feel about it, as though the artist were taking part in the new currents being developed in Italian art after 1470. The new trends are dictated primarily by the great popularity that Netherlandish painting was enjoying, particularly in Urbino. The most descriptive and 'miniaturistic' aspects of Netherlandish painting are echoed in the Brera altarpiece in the Duke's shining armour, for example, and in the stylized decoration of the carpet. Netherlandish art was popular among the patrons of the period as well, as we can see by the rings on Federico's hands, which Piero had painted by Pedro Berruguete, a Spaniard with a Northern training.

The other aspect of this painting that must not be underestimated is its similarity with the new developments of Florentine painting, visible primarily in the work of Verrocchio and some of his young pupils. The angels' garments are decorated with jewels and with huge precious brooches, their hair is held back by elegant diadems: these elements, and even their melancholy expression, are certainly influenced by the recent developments in Florentine art. In the same way, St John the Baptist's and St Jerome's bony limbs, emaciated by deprivations in the wilderness, recall some of Verrocchio's studies; and the sleeping Child, in his extraordinary contorted position, anticipates some of the young Leonardo's drawings of putti.

Among Piero's surviving paintings, the last one in chronological order is the *Nativity* in the National Gallery in London. The missing patches of colour, which might almost indicate that the painting is unfinished, are in fact probably the result of overcleaning. The Child lies on the ground, on a corner of Mary's cloak, following traditional Northern iconography which is reflected also in the features of the Child. Other elements of Northern culture can be found in a few naturalistic details, interpreted in a highly original fashion by Piero, such as the strange figure of St Joseph, nonchalantly sitting on a saddle, or the two animals in the background, depicted with great realism. No landscape view of Piero's is as miniaturistic as the city depicted in the background at the right: even the streets and the windows of the buildings are visible, just like in a landscape by Petrus Christus. Even the composition of the painting is quite innovative compared to Piero's

90. Madonna of Senigallia
61 x 53 cm
Urbino, Galleria Nazionale

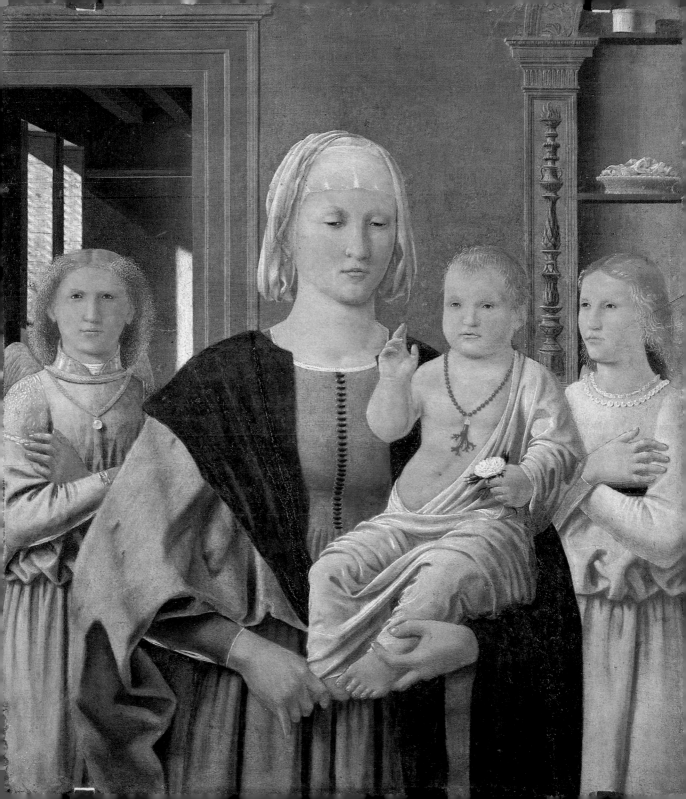

91

91. Interior of the church of Sant'Andrea, Mantua

92. Madonna and Child with Saints
248 x 170 cm
Milan, Brera

previous production. The wide expanse of ground, dotted with patches of grass, and the roofing of the hut, with its shadow projecting onto the ruined brick wall, seem to indicate an attempt by the artist to fragment the space of the picture, breaking the rule that he had always rigorously abided by. The vanishing point is slightly raised, as in the Brera altarpiece, and gives one an almost bird's-eye view of the spectacular river landscape, which extends into the distance with trees, bushes and sheer rockfaces that remind one of some of the young Leonardo's drawings.

These aspects of new perspective composition, of experimental naturalism and even of movement must be read as symptoms of the aging painter's incredible ability to update his art to the latest novelties being developed by Florentine and Netherlandish artists. But it is also clear that Piero could not have gone any further in this direction, for it would have meant abandoning the basic principles of his art. The directions that painters like Verrocchio and the young Leonardo were taking, with their almost scientific studies of action and movement, were leading too far away from the principles of spatial construction elaborated and developed by Piero and Alberti. Piero della Francesca's background culture, still very much alive in this last painting in the group of angels clearly inspired by Luca della Robbia's Cantoria in Florence Cathedral, was the 'heroic' environment of the early Renaissance, created in Florence by Brunelleschi and Donatello, by Leonardo Bruni and Paolo Toscanelli. Compared to the ideals of the earlier generation, the refined and courtly culture which was developing around the artistic patronage of Lorenzo the Magnificent, with its poetic Neo-Platonic abstractions and its archeological

97
96

nostalgia for the romantic nature of classical antiquity, must have seemed superficial and ephemeral—almost a betrayal of its origins.

Over the following years, Piero accepted several commissions in Borgo San Sepolcro, but the works he produced have all been lost: a fresco cycle in the church of Badia (1474), and a *Madonna* painted for the confraternity of the Misericordia in 1478, the last of his paintings mentioned in the documents of the time. In 1482 the artist is recorded as travelling to Rimini, where he rented a house; but we do not know whether he went there in order to paint something or not. These documents and his will, dictated in 1487, in which he is described as 'sound of mind, intellect and body,' suggest that he only became blind in the last years of his life, as Vasari states, and that he did not completely lose his eyesight until the 1480s. But none of Piero's works painted after 1475—the year of the London *Nativity*—have survived, and we have no real explanation of why Piero gradually stopped painting almost twenty years before his death (October 12, 1492). Certainly one of the reasons would have been his ill health and his growing blindness; but it is also probable that he felt that he wanted to examine further the theories behind those laws of perspective and proportions that, with the addition of his original and inventive talent, had contributed to the creation of his extraordinary pictorial compositions. Faced with the birth and development of a modern art so different from his, Piero della Francesca responded with his treatises *De Prospectiva pingendi* and *De Corporibus regularibus*, in which he analyzed the theoretical and scientific foundations of his pictorial culture. It is from his drawings in *De Prospectiva pingendi* that the per-

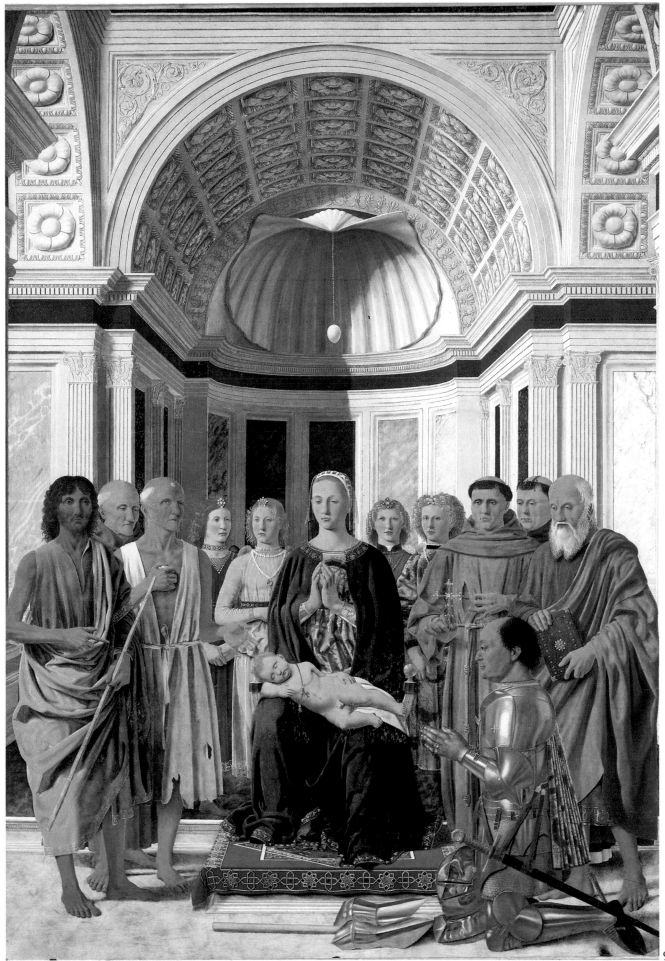

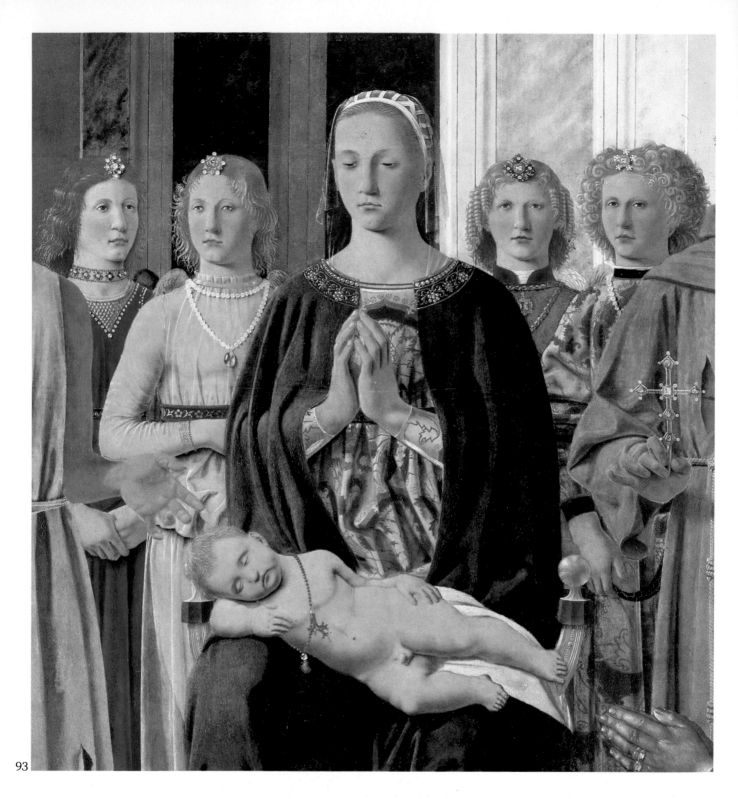

93

spective construction of the panel of the so-called
98 *Ideal City*, in the National Gallery in Urbino, is born.
This painting is so closely connected to Piero's theoret-
ical writings that it must have been painted by a very
close collaborator of his. This square, with its buildings
inspired by the architecture of Alberti, is perfectly in
harmony with Piero's ideals: the rational construction
and the depiction of Florentine palaces are both ideal
and realistic.

Piero della Francesca's two treatises, which, com-
pared to some of Alberti's splenid passages, are com-

93. Madonna and Child with Saints, detail
Milan, Brera

94. Nativity
124 x 123 cm
London, National Gallery

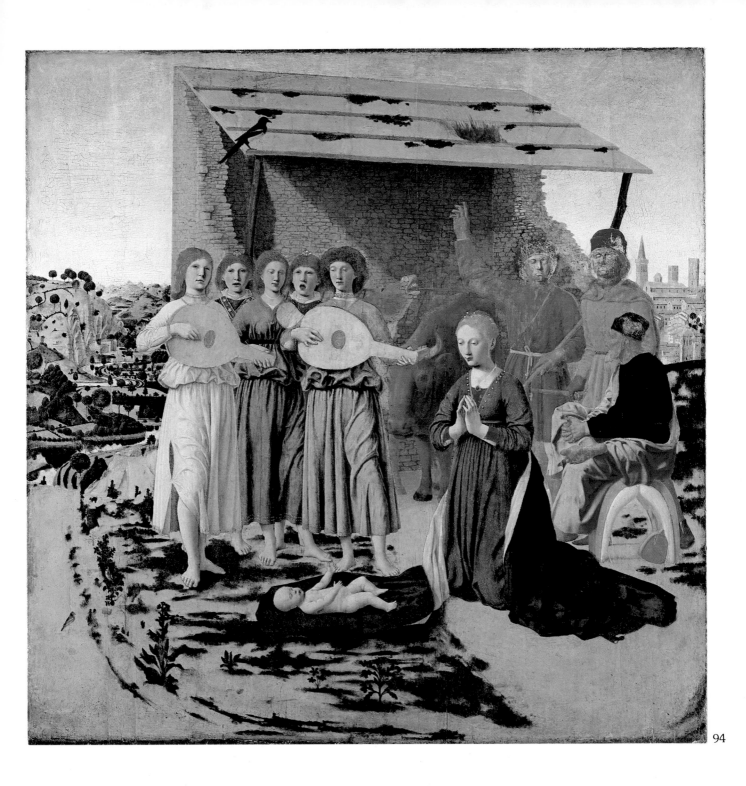

posed of dry mathematical calculations, are among the most important scientific texts of the 15th century. Leonardo da Vinci and Albrecht Dürer, as well as Piero's pupil Luca Pacioli, will later base their own work on these studies. A third text by Piero, the *Tratta-to d'Abaco* (treatise on abacus), has recently been published; this text has no connection with painting, for it is an entirely mathematical and practical study. As well as being the great intellectual that we have seen, the aging Piero did not think it unworthy of his talents to write 'some questions of abacus necessary for merchants. . . some mercantile procedures such as trading, credit and companies.' Once again we find evidence of

the close connection between art, science and mathematics which, from Brunelleschi onward, was one of the main elements of Italian Humanism—and perhaps the one that is most difficult for us to understand.

95

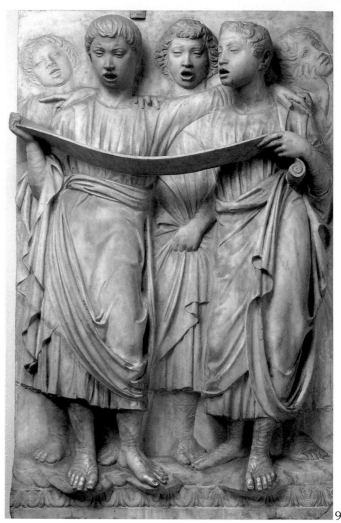

96

No study of Piero della Francesca, however short, can be complete without a mention of the deep mark his work has left on all Italian art and, as a consequence, on European art. Piero's influence, direct or indirect, was the determining factor in the conversion of vast areas of the art world to a new form of painting, a new vision based on a fully Renaissance concept of spatial depth. Equalled only by the developments produced by Donatello's works in Florence and Padua, Piero's art succeeded more than any other in explaining and teaching the principles of linear perspective, conceived as the only valid construction technique of any figurative composition. After leaving Florence around 1440, Piero della Francesca had travelled widely through central Italy's minor centres, where he had found an

art that was still fundamentally Gothic and bound by the artistic traditions of the past. Towards the end of his life, the artist was able to observe how, thanks largely to his own work, art based on linear perspective had definitely spread beyond the city walls of Florence, to large cities and small towns alike.

The interpretation of figurative space offered by Piero is completely different to Donatello's expressed in his Florentine works and primarily in his Paduan ones. Donatello gives his compositions a sense of space that is suggested, or hinted at, made up of sudden daring foreshortenings that create dramatic effects. In his reliefs for the altar of the basilica of Sant'Antonio in Padua, the sculptor even uses materials such as gold and coloured stones to enrich, enliven and give movement to his bronze surfaces; in a few square centimetres of a relief he succeeds in conveying the idea of an almost boundless space. In Piero's work, on the contrary, the strict unity of space is matched by the regularity of the composition, by the exaltation of shapes in their volumes and their colours; nothing is suggested or hinted at, everything is fully depicted.

These substantial differences between Piero's art and the prevailing Florentine tradition, where Donatel-

76

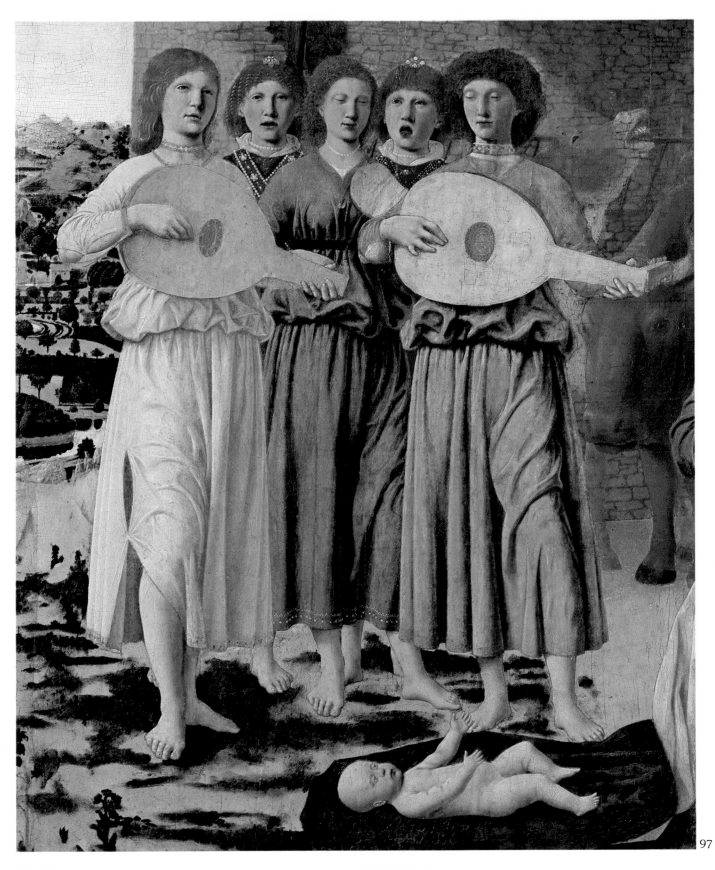

97

95. *Nativity, detail*
London, National Gallery

96. *Luca della Robbia*
Cantoria
Florence, Museo dell'Opera del Duomo

97. *Nativity*
detail of the musician angels
London, National Gallery

98

lo's innovations also influenced painting towards the middle of the 15th century, largely explain why the artist left Florence so soon and why he never returned. The Florentine painters closest to Piero are Alesso Baldovinetti and Andrea del Castagno, but the similarities are due more to their common training in Domenico Veneziano's workshop rather than to actual contact. In this respect, Andrea del Castagno is particularly interesting: while some of his monumental compositions, such as the frescoes today in Sant'Apollonia in Florence, are definitely reminiscent of Piero's art, Andrea is profoundly different, for he paid little attention to the delicacy of the paintbrush and created rounded figures that at times appear to have been carved out of rock. The great pictorial developments of the 1430s, that reached their height in the frescoes in the church of Sant'Egidio, did not last long; by around 1450 the most successful artists in Florence were Lippi, Pesellino and Gozzoli, who concentrated on an art based on modelling and drawing that will later achieve such extraordinary results in the work of Pollaiolo and Leonardo.

But Piero's heritage is really to be found in Venice, where from the early 1470s Giovanni Bellini showed the influence of Piero's works which he had seen in Urbino.

At the same time, Antonello da Messina, with works such as the *San Cassiano Altarpiece*, the fragments of which are today in Vienna, brings to the Venetian lagoon that sense of colour and atmosphere that characterizes the last frescoes in the church of San Francesco in Arezzo and which seems to have been transferred directly to the work of Bellini and Carpaccio. And, beyond Venice, the whole of the Po Valley area appears to understand Piero's message. To the north of Emilia, which, as we have seen, was one of the first areas to be influenced by Piero, Milanese painters follow the trends set by Bramante, whose theories of mathematical perspective were learnt in Urbino.

The older and more established artistic centres of central Italy renounce their local traditions to follow Piero's concepts of colour and space, as happens in

98. Ideal City
60 x 200 cm
Urbino, Galleria Nazionale

Perugia with the young Perugino and in Siena with Francesco di Giorgio and Pietro Orioli. Large areas of the Marches and the major area of Piero's activity—Arezzo, Cortona, Borgo San Sepolcro—are conditioned by Piero's art, as can be seen by the work of Bartolomeo della Gatta and the young Signorelli. And further south, from Rome with the works of Antoniazzo Romano and Melozzo da Forlì, to the countryside of Abruzzi, to the large southern cities like Naples, or the great Antonello's Messina—the art-historical map of Italy is profoundly altered by the spread of Piero della Francesca's art, a painting conceived as a 'perspective synthesis of shape and colour.'

Chronology of the Life and Work of Piero della Francesca

The asterisk indicates that the date is documented

1415-20 Piero della Francesca is born in Borgo San Sepolcro

* 1439 He works, together with Domenico Veneziano, on the frescoes in the choir of the church of Sant'Egidio in Florence; during this period he also paints the *Madonna and Child* in the Contini-Bonacossi Collection

* 1440 *Baptism of Christ (8)* in the National Gallery in London

* 1445 Contract for the polyptych for the confraternity of the Misericordia; he paints the panels with *St Sebastian* and *St John the Baptist (10)*

1445-48 *Angel* and *Madonna of the Annunciation, St Benedict, St Francis* of the Misericordia polyptych *(9), St Jerome and a donor (15)* in the Accademia in Venice

1449 Lost frescoes in Ferrara

* 1450 *Penance of St Jerome (16)* in the Gemäldegalerie Dahlem in Berlin

* 1451 *Sigismondo Malatesta and St Sigismund (17)* for the Tempio Malatestiano in Rimini; portrait of *Sigismondo Malatesta (19)* in the Louvre

1452 *Flagellation (21)* in Urbino; *St Bernardino* and *St Andrew (14)* of the Misericordia polyptych

1452-55 First frescoes in the church of San Francesco in Arezzo: *Death of Adam (25), Exaltation of the Cross (30), Prophets (40, 41). Madonna del Parto (60)* in Monterchi; *St Julian (61)* in Borgo San Sepolcro

1455-58 Second register of frescoes in Arezzo: *Meeting of Solomon and the Queen of Sheba (37), Discovery and Proof of the True Cross (45), Burial of the Wood (44), Torture of the Jew (43). Resurrection (63)* in Borgo San Sepolcro

* 1458-59 Frescoes in the Vatican, now lost

1460-62 *Madonna and Members of the Confraternity (65)* of the Misericordia polyptych. Third register of frescoes in Arezzo: *Annunciation (53), Constantine's Dream (52), Battle between Constantine and Maxentius (49), Battle between Heraclius and Chosroes (54).* Central panel *(68)* of the polyptych in the Pinacoteca Nazionale in Perugia

1462-64 Completion of the decoration in Arezzo: *Angel (59), St Peter Martyr, Eros.* Predella *(71-75)* of the Perugia polyptych. *Mary Magdalen (66)* in Arezzo Cathedral

1465 Diptych of the *Duke and Duchess of Urbino (84, 85, 87, 88)*

1465-70 *Annunciation (76)* for the Perugia polyptych. Polyptych for the monastery of Sant' Agostino in Borgo San Sepolcro. *Hercules (83)* in Boston

1470-72 *Madonna of Senigallia (90). Madonna and Child with Angels (89)* in Williamstown

1472-74 *Madonna and Child with Saints (92)* in the Brera Gallery in Milan

1475 *Nativity (94)* in the National Gallery in London

Basic Bibliography

G. VASARI, *Le vite de' più eccellenti pittori scultori e architettori italiani*, Florence 1568

G. B. CAVALCASELLE-J. A. CROWE, *History of Painting in Italy*, London 1864

A. VENTURI, *Storia dell'Arte*, Milan 1911, VII, I, pp. 434-486

R. LONGHI, *Piero della Francesca e lo sviluppo della pittura veneziana*, 'L'Arte', 1914, pp. 198-221, 241-246

G. MANCINI, *L'opera 'De corporibus regolaribus' di Pietro Franceschi detto della Francesca*, in 'Atti della R. Accademia del Lincei – Memorie della classe di Scienze Morali Storiche e Filologiche', series V, vol. XIV, pp. 446-487, Rome 1915

G. GRONAU, *Piero dei Franceschi*, in Thieme-Beckers Künstlerlexikon, XII, 1916, pp. 289-294

R. LONGHI, *Piero della Francesca*, 'Valori Plastici', 1927

P. TOESCA, *Piero della Francesca*, Enciclopedia Italiana, vol. XXVII, 1935, pp. 208-213

G. NICCO FASOLA, *Il trattato 'De Prospectiva Pingendi' di Piero della Francesca*, Florence 1942

B. BERENSON, *Piero della Francesca o dell'arte non eloquente*, Florence 1950

K. CLARK, *Piero della Francesca*, London 1951

H. FOCILLON, *Piero della Francesca*, Paris 1952

P. BIANCONI, *Piero della Francesca*, Milan 1957

D. FORMAGGIO, *Piero della Francesca*, Milan 1957

A. PARRONCHI, *Studi sulla dolce prospettiva*, Milan 1964

G. PREVITALI, *Piero della Francesca*, Milan 1966

A. BUSIGNANI, *Piero della Francesca*, Florence 1967

O. DEL BUONO, P. DE VECCHI, *L'opera completa di Piero della Francesca*, Milan 1967

PIERO DELLA FRANCESCA, *Trattato d'Abaco*, edited and introduced by G. Arrighi, Pisa 1970

E. BATTISTI, *Piero della Francesca*, Milan 1971

M. MEISS, *La sacra conversazione di Piero della Francesca*, 'Quaderni di Brera', 1971

M. SALMI, *La pittura di Piero della Francesca*, Novara 1979

C. GINZBURG, *Indagini su Piero*, Turin 1981